IMAGES
of America

PEACHTREE CITY

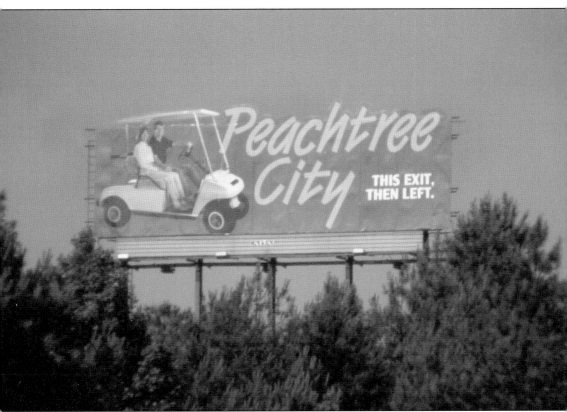

According to figures given in a 1991 publication by the Urban Land Institute, Peachtree City Development Corporation was spending nine percent of its advertising budget on billboards and signs in an effort to market the city. One billboard in the early 1970s, targeting commuters coming home from Atlanta on Interstate 85, was situated over 10 miles outside of the city. The eye-catching phrase on that one? "No billboards in Peachtree City." The billboard above, though still outside the city, focused on selling the community-minded lifestyle. The city ordinances of Peachtree City still prohibit billboards within the city. (Courtesy of Joel Cowan History Room, Peachtree City Library.)

ON THE COVER: In April 1976, *This Week* announced that Garden Cities Corporation would be showing visitors around the city by special electric cars, provided by HMK Marketeer, Ltd., of Peachtree City. A "cart barn" was built to house the bicentennial carts, painted red, white, and blue. In the photograph, Maurice Brown Jr. (right) of Garden Cities Realty talks to visitors Dennis and Janella Krier. (Photograph by Warren L. Bond Studios.)

IMAGES
of America

PEACHTREE CITY

Rebecca Watts, Ellen Ulken,
and Clarence Lyons

ARCADIA
PUBLISHING

Published by Arcadia Publishing
Charleston, South Carolina

Printed in the United States of America

Library of Congress Control Number: 2008941301

For all general information contact Arcadia Publishing at:
Telephone 843-853-2070
Fax 843-853-0044
E-mail sales@arcadiapublishing.com
For customer service and orders:
Toll-Free 1-888-313-2665

Visit us on the Internet at www.arcadiapublishing.com

Contents

ACKNOWLEDGMENTS

I would like to thank my collaborators Ellen Ulken and Clarence Lyons for all of the hard work, friendship, and encouragement provided during this project.

Rebecca, Ellen, and Clarence would like to thank their spouses—Tom Watts; Jerry Watts, M.D.; and Janice Lyons (respectively)—for their patience and support while we worked on this book.

Unless otherwise noted, all images appearing in this book were provided by the Joel Cowan History Room, Peachtree City Library.

The authors consulted a variety of resources in compiling this book. Most notably were Carolyn Cary's *The History of Fayette County 1821–1971*; George Chapman's *Chief William McIntosh, A Man of Two Worlds*; Rita F. Elliot's *Archeology at the Falcon Field Site*; Hubbard and Anderson's *The Fayette County Georgia Heritage Book*; Charlie Nelson's *The Guide*; Frank Hyde's *In Clover*; Fayette County Historical Society's *Cemetery Records, Fayette County, Georgia*; Frances Reeves's *A Short History of Fayette County Georgia, 1821–1977*; and the newspapers *This Week in Peachtree City* and *Fayette County News*.

We are grateful to the following people without whom this brief history-telling would have been so much less: Jimmy Booth for having started *This Week* and for having the back issues bound during his reign as publisher and given to the library.

Joel H. and Geri Cowan for their help and encouragement.

The folks at the Fayette County Historical Society for their enthusiasm and assistance, especially Doug Adams, Lamar McEachern, Tony Parrott, and Sandra Woods.

Sandra Prince and Pathways Communities.

Carolyn Cary, Mary Maud Hiestand, and Sally Satterthwaite for their assistance and encouragement along the way.

E. Lee Eltzroth for her friendship (and connections!); Joe Lee; Erick D. Montgomery of Historic Augusta, Inc.; Patricia Knox Hudson, Barbara Huddleston Phillips, and Maggielene Knowles Robertson, who provided important early photographs; Frances Meaders for remembering who to ask; Marcie Curry Williams for stashing the big box of pictures; Randy Gaddo, Dave Piet, and Geraldine Holt, who began the Peachtree City Oral History Project; Anne Eldredge of FayetteFrontPage.com; Tony Bernard of the Peachtree City Building Department; Peachtree City Library Corporation (a Friends of the Library affiliate).

Staff of the Peachtree City Library for their patience, support, and encouragement.

Citizens and city employees who joined us in the Floy Farr Room of the library to identify photographs.

And to the following folks for their enthusiasm and assistance telling great stories and/or providing photographs, many of which will have to wait for the next history book to be written: Darrell Adams (great-grandson of W. T. B. Gordy), M. T. and Glen Allen, Danny Allen, Ruth Asci, former mayor Frederick Brown Jr., Fred Brown (of Brown's Guides), Melvin Brown, Maj. Mike DuPree, Freddy Frank, Dolly Morgan, Peachtree City Garden Club, Peachtree City Running Club, Jerry and Julie Peterson, James Robison, Roy Robison, Matt Robinson, Jim and Marilyn Royal, Southeastern Archeological Services, Inc., Paul Talbott, Betsy Tyler, Anita Vaughan, and Joe Wiegele.

Posthumously, thanks to Walter Floy Farr, who I had the pleasure of meeting in his later years, and Bob Bivens, who sent the library a box of historical photographs and documents a few years prior to my getting involved in the accumulation of the city's history.

And, finally, thanks to Jill Prouty, MLS, Peachtree City Library Administrator, who I can call boss and friend and who, like a good friend, got me into this.

Rebecca Watts, MSLIS

INTRODUCTION

Until the Treaty of 1821, Creek Indians owned the land that became Peachtree City. Called Creeks by the white man because they colonized along waterways, they called themselves Muscogee. The Upper Creeks lived west of the Chattahoochee River, and the Lower Creeks were centered in present-day Columbus, Georgia.

Carved from Creek Indian lands, Fayette County was named for General Marquis de LaFayette. Fayetteville, the county seat, was incorporated in 1823, when land lots of 202.5 acres each were awarded by grant.

Early pioneers, mostly farmers of Scotch, Irish, English, or African stock, came from the Carolinas, Virginia, and east Georgia. Most depended on their families to work the land. Some brought mules and oxen for plowing. Vegetables, wheat, oats, and sugar cane were grown for home use. Pork was the common meat, with fish and game adding variety.

Militia districts formed to keep order. The Shakerag Militia District spanned the area that became Peachtree City. Kedron, an early settlement within the district, vanished when the railroad came through. Clover and Aberdeen became railroad communities; both were trade and social centers where locals gathered to talk while their corn pressed through the "millrocks" or their cotton was ginned.

Prior to World War II, few roads were paved. Sprinkled with farms, the land over which Peachtree City emerged was so rural that electricity did not arrive until 1947 nor telephones until the early 1950s.

Into this landscape, in 1956, came two real estate agents.

FROM FLOY FARR'S ORAL HISTORY:

Earl Denny and Golden Pickett entered the Tyrone bank and told Floy Farr they wanted to buy some land.

"Well, how much land?" asked Farr.

"Fifteen thousand acres," they replied.

"That's a lot of land. What are you going to do with it?"

"Build a city," they said.

Farr put them together with local landowner Robert H. Huddleston, who agreed to arrange the sale of options on several thousand acres. But Pickett and Denny did not have any money to pay the landowners. They approached Peter S. Knox Jr. of Thomson, Georgia, builder of prefabricated houses, and Knox was interested.

"Mr. Knox put a little money in the bank, and we got an attorney, and we started to take options on the land," said Farr.

All the while, the locals were buzzing. "Who are those land grabbers? Want to build a town—in that swampy farmland? Are they nuts?"

Industrial management student Joel H. Cowan still had another year at Georgia Tech when he was hired by Pete Knox Jr., in 1957, to supervise the land.

FROM JOEL COWAN'S ORAL HISTORY AND TIMELINE:

"Pete Knox was a true visionary and saw immediately the prospect for such vast acreage so near Atlanta. Knox had read a book about the British new towns, also known as satellite cities, and was fascinated by the prospect of such in Atlanta."

"I spent some of that summer . . . meeting all these people [in Shakerag] and learning to sit around the Dave McWilliams' store. I couldn't chew tobacco or spit, but that's what they did around the pot-bellied stove . . . the mission was to keep them from foreclosing and to keep the options alive on the property."

"The truth is, Denny didn't know where the land was and most of the land owners didn't know specifically. There were deeds in there that said go to the creek where there's a hickory tree with a horseshoe hanging on the limb and that was the corner." There were militia districts, land districts, and land lots. "Of course, we didn't have the money to survey it. None of this land was surveyed back then." Trying to figure out where the lots were and finding the money to buy the land were what drove the project in the beginning.

The town was named Peachtree City, to convey its link with Atlanta and to encourage industrial development, which would be vital to the city's future.

In the fall of 1959, Joel sought a dam site for Lake Peachtree. Planners had sketched a lake north of Highway 54 and illustrated the town along its shores. Joel and Tom Mitchell, armed with dynamite and a plunger, blew up beaver dams all through the swamp, where the dam was supposed to extend. When the beavers kept rebuilding, Joel took his problem to McWilliams' store. Sitting around the potbellied stove, Hugh Huddleston suggested another spot for the dam, where Flat Creek narrowed about a mile below Highway 54, and Joel went there with Tom Mitchell, following the creek through the woods. "And when I saw it, I knew that was the place," said Joel.

During the 1960s, industrial plants, one after the other, built up along the main road through the Industrial Village. And Joel Cowan laid the framework for his town. Garden Cities Corporation developed marketing plans in the early 1970s and worked with the city government to fashion a town where people would "plan to stay." Neighborhoods began to flesh out. Aberdeen and Glenloch Villages were the first two to have their shopping and worship centers in place. Community gardens, athletic fields, and Glenloch Stables provided recreation, as did the first 10 miles of bicycle paths that would eventually expand into an extensive secondary roadway.

The 1970 population was 738, but with new houses going up, by the time Jimmy Booth established his newspaper *This Week* in 1974, the number was nearing 3,800.

The year 1976 was a significant year for the nation, and Peachtree City found a unique way to contribute to the country's 200th anniversary. *The McIntosh Trail* open-air drama was to see its one and only season that summer. The play dramatized the importance in Georgia history of Chief William McIntosh. McIntosh was murdered in 1825 by a mob of Upper Creek Indians, angry that he had signed away more land in the Treaty of Indian Springs.

The transition of Garden Cities Corporation into Pathway Communities in the late 1970s stirred up a new focus on selling the city's image. People poured into town as word got out that the amenities were superb and the lifestyle enviable. Braelinn Village developed during the 1980s. Dining and shopping choices were limited in the third and fourth decades of the city's life, but as the new millennium approached, they began to flourish.

By the 1990 census, 20,000 people had moved to Peachtree City for its excellent schools, safe neighborhoods, and convenient commute to the airport or downtown Atlanta. Kedron Village was in the initial stages of development. And West Village with Planterra would not be far behind.

As Peachtree City turns 50, it still struggles with the timbre of a "new town." While fuel prices fluctuate, all agree that the culture of the golf carts and the multiuse paths to support them were some of the many things the city elders got right. Green space continues to be valued and protected.

Despite controversy, we now have Home Depot, Wal-Mart, and Target stores, but they are tucked behind landscaped hills in areas planned for shopping. Housing possibilities range from apartments and condominiums to starter homes to executive manors. And the library, the fourth busiest in the statewide PINES consortium, is a focal point for the city situated next to city hall near Lake Peachtree, city parks, and playgrounds.

It looks as though Georgia's first "new town," now with 36,000 people, while different from its architect's first vision, can only be called a tremendous and established success.

One

ON THE EVE OF PEACHTREE CITY

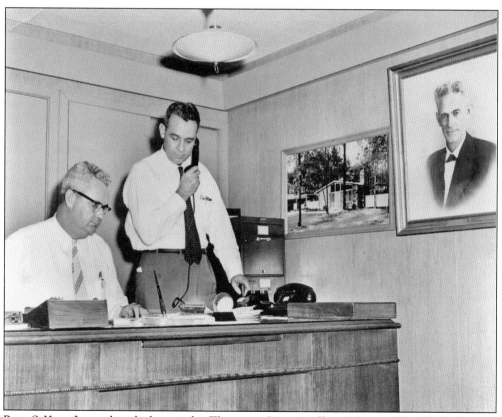

Peter S. Knox Jr., on the telephone in his Thomson, Georgia, office with an unidentified colleague, had the vision that became Peachtree City. Knox developed a prefabricated home business and then became intrigued with the "new towns" started in England after World War II. Designed as solutions for war-torn London and as an alternative to uncontrolled development and suburban sprawl, the movement for such planned communities in the 1950s and 1960s eventually led to many attempts at "new towns" in the United States. Some of the more successful were Reston, Virginia; Columbia, Maryland; and, of course, Peachtree City, Georgia. (Courtesy of Patricia Knox Hudson.)

Peter Knox III, a year ahead of Joel Cowan at Georgia Tech and majoring in industrial engineering, would go on to be a force in preservation of historic Augusta, an interesting contrast to his fraternity brother's involvement in a "new town." Still a young man in this picture from 1968, he passed away in 1996 at the age of 61. (Photograph by Frank O. Sherrill Jr.; courtesy of Patricia Knox Hudson.)

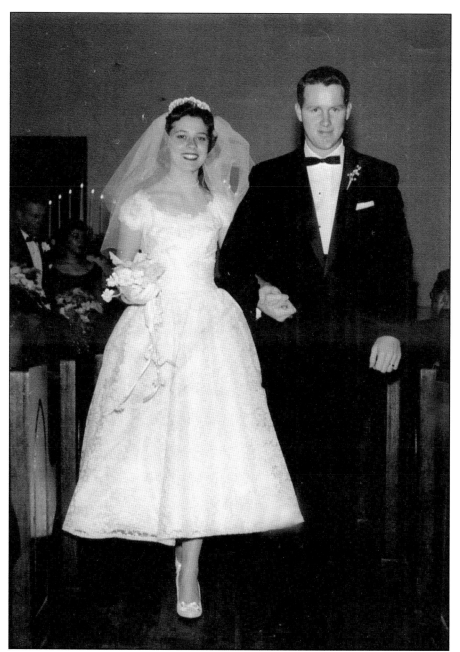

Joel H. Cowan, who would become the first mayor and driving force in the building of Peachtree City, was a junior in industrial management at Georgia Tech in 1957. Cowan was from Cartersville, Georgia, where his father was mayor. One of Cowan's fraternity brothers at Tech was Peter S. Knox III, whose father was dreaming of building a "new town." The elder Knox was impressed with Cowan and asked him to take on the project of the new city, which did not yet exist. Joel took his new bride, the former Geraldine Matthews, who had grown up as one of nine children on a farm outside of Roswell, Georgia, to the wilds of west Fayette County, where they established their first home on Shakerag Hill. This December 1957 wedding picture was taken by a coworker of Geri's at Lockheed in Marietta. (Courtesy of Geri Cowan.)

Robert Hamilton Huddleston was born on January 22, 1883, the 25th of 26 children. "Mr. Bob," a farmer, acquired property along Old Highway 74 from Highway 54 to Senoia. He served as county registrar and on the Board of Education. From 1933 until 1939, he was the assistant county agent, helping to launch the Federal Farm Assistance Program. He served more than 50 years on the board of directors of the Farmers and Merchants Bank. In his later years, he served on the first Peachtree City Council. A pond, two roads, and a school are named for Huddleston. He died in 1974. (Courtesy of the Fayette County Historical Society.)

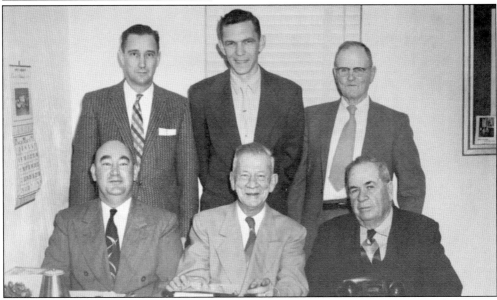

Floy Farr (standing at left) was a young community leader in 1956 and member of the Fayette County School Board (pictured above) along with Bob Huddleston (seated at right). He was also manager of the Redwine Bank in Tyrone when two real estate agents, Earl Denny and Golden Pickett, came to the bank to inquire about buying land—15,000 acres to build a new city. An astonished Farr sent the agents to check out the Shakerag area and talk with Bob Huddleston, the largest landowner around and also a member of the Fayette County School Board. With $330,000 available initially, the agents, with Farr's help, began buying the farmland that would become Peachtree City. The original investment group in 1957 was the Fayette County Development Corporation (FCDC). On July 30, 1959, the FCDC, with funding from the Bessemer Corporation, reorganized and became the Peachtree Corporation of Georgia, which would develop the new city. The directors of the Peachtree Corporation included Pete Knox Jr., James F. Riley Jr. of Bessemer, and others. (Courtesy of the Fayette County Historical Society.)

In 1956, change—big change—was about to begin in western Fayette County, Georgia, 25 miles south of Atlanta. Several men with a vision to build a new planned city were about to remake this sparsely populated farming area of cornfields, pine trees, small streams, and small crossroad communities.

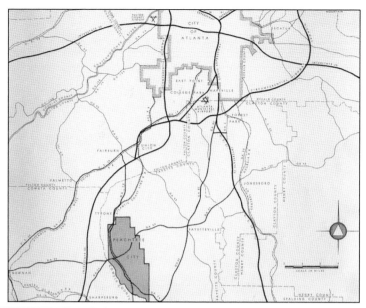

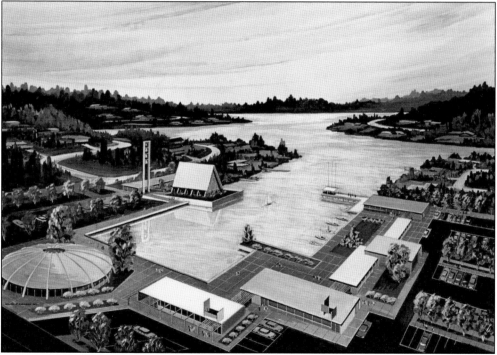

The "new city in Georgia" began as a vision but needed a plan to become a reality. Willard C. Byrd and Associates developed a futuristic concept for a complete new city based on controlled development and planning to avoid the sprawl so dominant in most metropolitan areas of America. Individual residential neighborhoods near a lake, schools, parks, and other community facilities would be complemented by surrounding office and commercial areas. A separate industrial park would be established. The 15,000-acre city was to become a "complete" city in which to live, shop, and work—all the advantages of small-town living with proximity to the "big city" of Atlanta 25 miles north.

Peachtree City's official birth date is March 9, 1959, when Gov. S. Ernest Vandiver Jr. signed an act granting a charter to the new city. Young Joel had fashioned the document using the language from other town and city charters, and the full document is 40 pages long. The legislation designated a city council of Robert H. Huddleston, R. Hugh Huddleston, John E. Robinson, J. A. Pollard, and Joel H. Cowan as mayor. Robert H. "Mr. Bob" Huddleston was the father of Grady and R. Hugh Huddleston. Interestingly, Governor Vandiver owned a small amount of stock in the Fayette County Development Corporation, which he had purchased through his friend Peter Knox Jr. (Courtesy Georgia Archives.)

14

Grady L. Huddleston, who represented Fayette County in the Georgia House of Representatives, introduced the legislation creating Peachtree City. The bill was cosponsored by Harry H. Redwine, the state senator from the area. (Grady Huddleston, Biographical Questionnaires, Georgia Historical and Statistical Register, RG 4-10-74, Georgia Archives.)

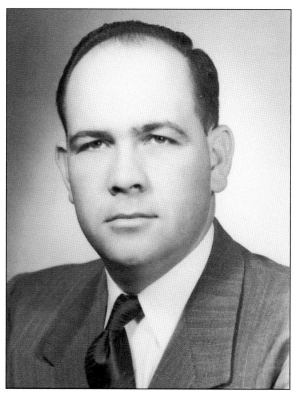

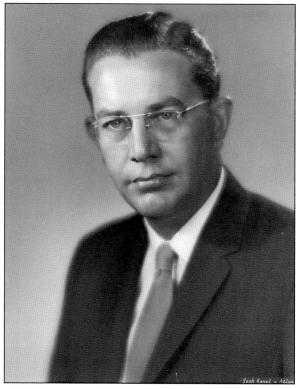

S. Ernest Vandiver Jr., governor of Georgia from 1959 to 1963, signed the bill creating the new town of Peachtree City on March 9, 1959. As governor, he cleaned up corruption, presided over the peaceful integration of the University of Georgia, and oversaw the revision of the county unit system of state elections. Vandiver farmed and practiced law in Lavonia for many years and died at home in February 2005. (S. Ernest Vandiver Jr., Biographic Questionnaires, Georgia Historical and Statistical Register, RG 4-10-74, Georgia Archives.)

ENROLLMENT

H. B. No. 242

March 2, 1959

The Committee of the House on Auditing, Enrolling, Engrossing and Journals has examined the within and finds the same properly enrolled.

Black of Webster

Chairman

Geo. L. Smith II

Speaker of the House

Glenn W. Ellard

Clerk of the House

Garland T. Byrd

President of the Senate

George D. Stewart

Secretary of the Senate

Received *Peter Zack Geer*
Secretary, Executive Department

This 2 day of March 1959

Approved

S. Ernest Vandiver

Governor

This 9 day of March 1959

General Assembly

AN ACT

To create and incorporate Peachtree City, in the County of Fayette, and for other purposes.

IN HOUSE

Read 1st time Feb. 2, 1959
Read 2nd time Feb. 3, 1959
Read 3rd time Feb. 5, 1959

And *Passed*

Ayes 120 Nays 0

Glenn W. Ellard

Clerk of the House

IN SENATE

Read 1st time Feb. 6, 1959
Read 2nd time Feb. 13, 1959
Read 3rd time Feb. 17, 1959

And *Passed*

Ayes 35 Nays 0

George D. Stewart

Secretary of the Senate

By: Mr. Huddleston of Fayette

This is the signature page of Act No. 148, which incorporated the city of Peachtree City on March 9, 1959. (Courtesy of the Georgia Archives.)

Two

A LAND WITH A LONG HISTORY

Chief William McIntosh (1775–1825) was a colorful, wealthy, and influential man, the son of Scotsman William McIntosh and a Creek Indian princess, Senoia He-ne-ha of the Wind Clan. His properties were connected by the McIntosh Road, extending from a point east of Indian Springs through Georgia, including the southern tip of Peachtree City, across the Chattahoochee River, and into present-day Alabama. McIntosh was fluent in both the Muskogee and English languages and wore the colors of his Scottish clan together with his Native American regalia. He loved his tribesmen as well as he did his white brothers and knew that if the tribes refused to sell their land, the settlers would take it by force or fabricate treaties to get it. McIntosh envisioned the eventual merging of Native American and white societies. He urged his people to sell their Georgia territory to the U.S. government, travel to Oklahoma, where they had been promised acreage, and learn the ways of the white man. Chief McIntosh's attempt to make peace with both natives and immigrants resulted in his tragic murder. (Photograph by Warren L. Bond Studios.)

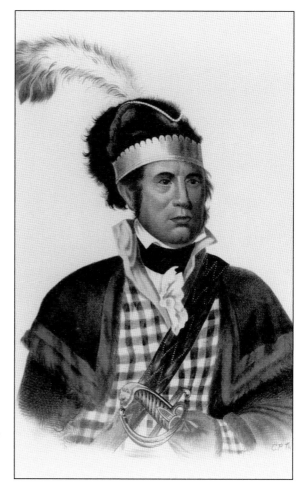

Before the airport expansion in 1988, Peachtree City commissioned an archeological study of the area. No large-scale excavations had ever been conducted in Fayette County or anywhere along the headwaters of the Flint River drainage system. During the dig, soil was sifted to catch even the smallest artifacts. Hearths (Native American fireplaces) and fire-cracked rock were found, as well as charcoal and residue from stones that had been chipped into tools or projectile points. (Both courtesy of Southeastern Archeological Services, Inc.)

Early Archaic (8000–6000 BC), Middle Archaic (6000–3000 BC), and Woodland (800 BC–900 AD) Indian tribes left evidence of their settlements along Line Creek and at present-day Falcon Field Airport, but they appear to have been short-term occupiers. The Late Archaic (3000–800 BC) tribes stayed for 2,000 years and left tools, shards of pottery, and stone hearth remains. One hearth contained a soapstone bowl fragment. From the dark-colored chert found at the site, not available locally, the archeologists learned that the Native Americans traveled and perhaps traded. The site lay undisturbed from the time of the departure of the Woodland Indian camps in 900 AD until the Europeans arrived in 1823. Artifacts, notes, and data from Line Creek and Falcon Field Sites are permanently located in the Laboratory of Archeology at the University of Georgia in Athens. (Both courtesy of Southeastern Archeological Services, Inc.)

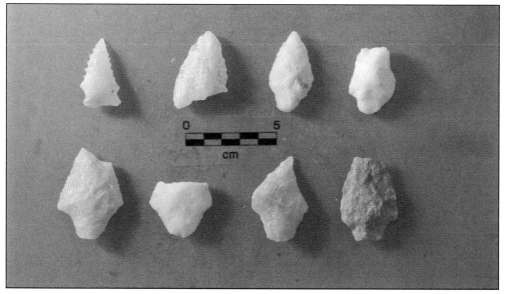

Alexander Ware was one of the first landowners in the area along Line Creek and the first representative from Fayette County to the Georgia Legislature. George Washington Ware followed his great-uncle Alexander to Fayette County, and for $300 in 1823, he bought land where Flat Creek Golf Course is today. A woolen mill, near the creek, produced socks. The gristmill he built there, Ware's Mill, powered by the waters of Flat Creek, became Leach's Mill, then Russell's Mill and Tinsley's Mill, according to a succession of owners' names. In 1930, Russell's Mill ground corn into meal. Lillian and Oliver Brown were the millers for many years, and with normal water flow, they ground eight bushels of corn per hour. When the dam broke in 1936, G. O. Tinsley bought the mill, powered it with gas, and ran it until 1960 when the land was sold to Phipps-Harrington Land Company. Tinsley's Mill stood in its place on the Flat Creek Golf Course until a fire destroyed it in January 1989. (Courtesy of the Fayette County Historical Society.)

Nathaniel and Susannah Stinchcomb, kin of the Civil War soldier Phillip Stinchcomb born in 1847 (shown here), lie buried in the family cemetery along Highway 54, between Peachtree Parkway and Lake Peachtree. They had 11 children. An original land lot grantee, Nathaniel started out with 202 acres in the 624th Militia District and was one of three Shakerag landowners selected to care for the families of soldiers who were away fighting the Civil War. (Courtesy of the Fayette County Historical Society.)

Where Robinson Road, Stagecoach Road, and Highway 54 converge on a hill, the community of Shakerag emerged. Small-claims court and elections were held in this tiny courthouse. The name "Shakerag" may have resulted from election disagreements among the residents in the area. Legend has it that after a fight, the victor hung the tattered clothing of the defeated on a fence post to blow in the wind. The little courthouse no longer exists. (Courtesy of the Fayette County Historical Society.)

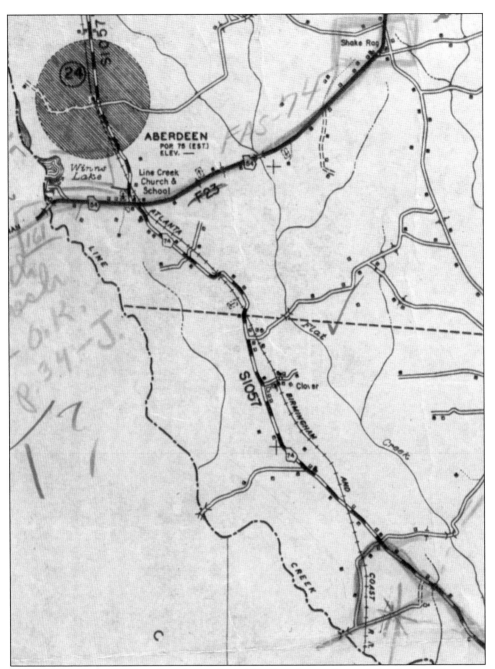

In the 1850s, Edward William Leach purchased land in the settlement that became known, at the end of that century, as Aberdeen. Aberdeen eventually had four grocery stores and a cotton gin. Some of the store owners were Charlie Whitlock, Will Parrott, Abon Brown, Neal Cochran, Charles Martin, Will Brown, and a Mr. Kirkland. After the railroad arrived, a depot was added. Hershel Grantham ran a sawmill in Aberdeen. When a post office opened in 1910, the population of Aberdeen was 150. John W. Kirkland was the first postmaster. This portion of a 1940 map shows the relative distance between the early communities of Aberdeen, Clover, and Shakerag. (Courtesy of Hargrett Rare Book and Manuscript Library/University of Georgia Libraries.)

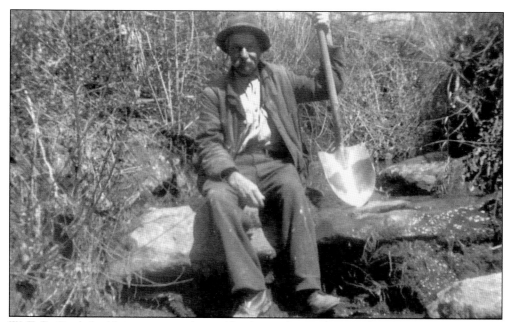

W. T. B. Gordy had his pottery works in Aberdeen a few yards east of Highway 74, near what is now Wisdom Road. From 1908 until 1918, he formed and fired butter churns, crocks, and jugs there. Clay, dug from Line Creek and possibly Wynn's Pond, was hauled to the plant with a mule wagon, placed in a pit, and kept damp until it could be shaped on the potter's wheel. Here is a later picture of Gordy mining for clay. (Courtesy of Darrell Adams.)

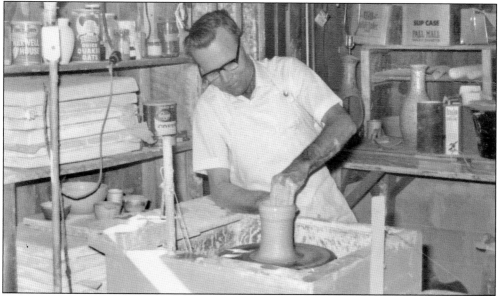

W. T. B. Gordy's second son, D. X., was born in Aberdeen, Georgia, in September 1913. D. X., following in his father's footsteps, became a potter and worked in Meriwether County for many years. He continued to fire his pottery in a homemade brick kiln over a 36-hour interval. Carolyn Cary interviewed D. X. for an article in *The History of Fayette County* in 1970. D. X.'s brother, W. J. "Bill" Gordy, also became a successful potter with a studio in Cartersville. (Photograph by Carolyn Cary; courtesy of the Fayette County Historical Society.)

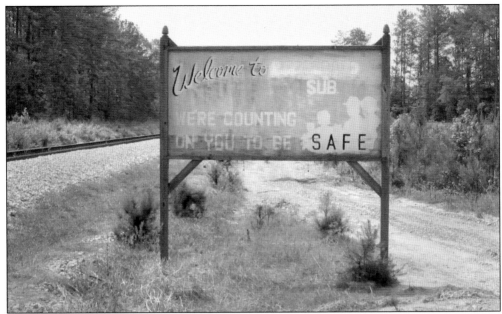

The Clover settlement formed about 4 miles south of Aberdeen when the Atlanta, Birmingham, and Atlantic Railroad came through. At first, it was a flag station. To stop the train, passengers flagged it with a handkerchief. The conductor acknowledged the flagger with two short blasts of his whistle and stopped to take him aboard. In 1916, a depot was built, and the Blalocks erected a store and gin house close by. (Photograph by Rebecca Watts.)

Organized in 1867, the Bethlehem Baptists worshipped under a brush arbor until James A. Arnold donated land in 1878. There, in the community of Clover, a church was built. In 1914, a new church replaced the old one and took the name Bethlehem Baptist Church. (Courtesy of the Fayette County Historical Society.)

In 1904, before the new church was built, Frank Rainey, Anderson Thompson, and Tuck Penson spent $31.25 for a tract of land to be used as a cemetery. Close to the railroad tracks, near the Industrial Park, the cemetery property is 1 acre wide and 2.5 acres long. (Photograph by Rebecca Watts.)

The Bethlehem Baptist Church has had several renovations and was designated a historical site in 2005. Many members descend from the original congregation. Eight ministers have served the fellowship over 140 years, including the present pastor, Dwight D. Elder. (Photograph by Ellen Ulken.)

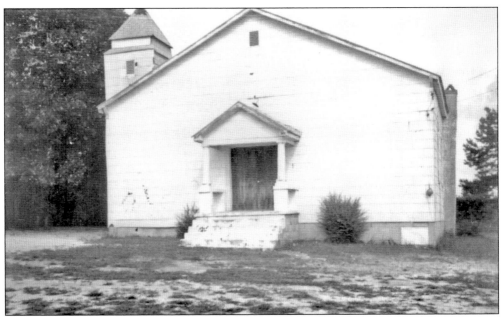

The Holly Grove African Methodist Episcopal Church was founded in 1897, on land donated by Flem Arnall. Until the first sanctuary was built, worship services were held under a brush arbor and in homes. In the early years, the congregation met once a month. The building shown is the 1944 structure, which replaced one destroyed by a tornado. This building was renovated in the 1950s and replaced by a brick structure in 1980. The above photograph represents the church after the 1950 renovation. The present building, constructed in 1980, was annexed into 28-year-old Peachtree City in 1987. (Above courtesy of the Fayette County Historical Society; below courtesy of Ellen Ulken.)

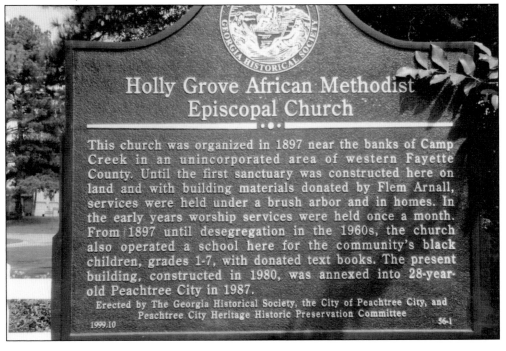

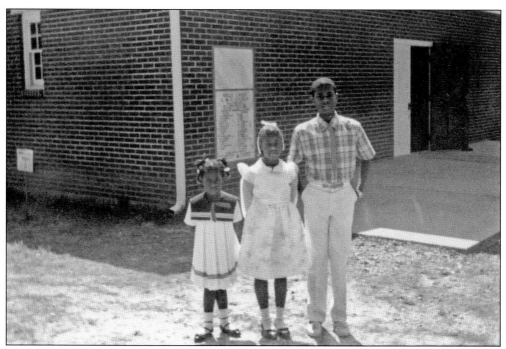

This picture was taken after a weekly Sunday school session in 1986. The children of Willie Murry pose in front of the dedication marker. From left to right, they are Kristal Murry, Shenita Murry, and Dorian Murry. (Photograph by Willie Murry.)

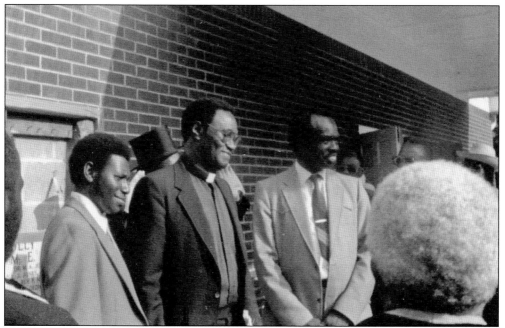

In 1985, the men in front of the Holly Grove African Methodist Episcopal Church include, from left to right, James Gresham, a visiting pastor, and pastor Michael L. Jones. James Gresham started and led the all-male chorus at Holly Grove church, which still exists. (Photograph by Willie Murry.)

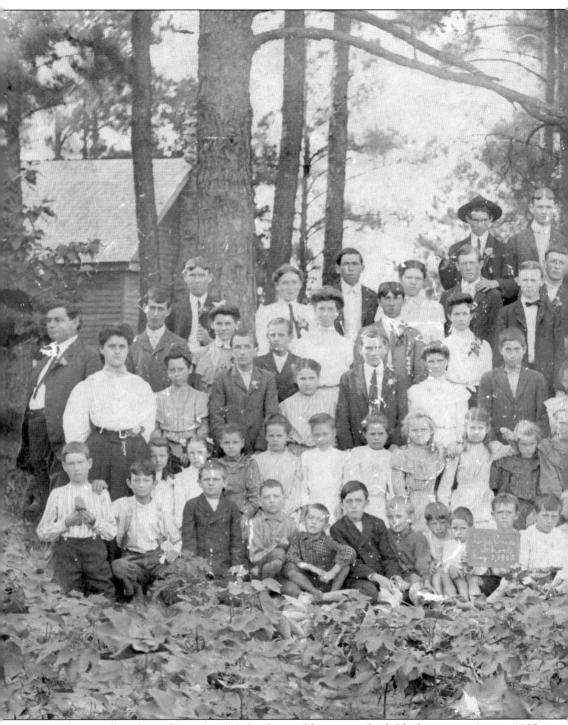

Students and teachers of Line Creek School assemble in a nearby field of cotton in August 1905. Prof. W. M. Spear and his assistant, Georgia Arnall, are seen at the far left of the picture. The school calendar was scheduled around the planting and harvest seasons, with classes meeting January through March and again in July and August. The students were not separated by grade,

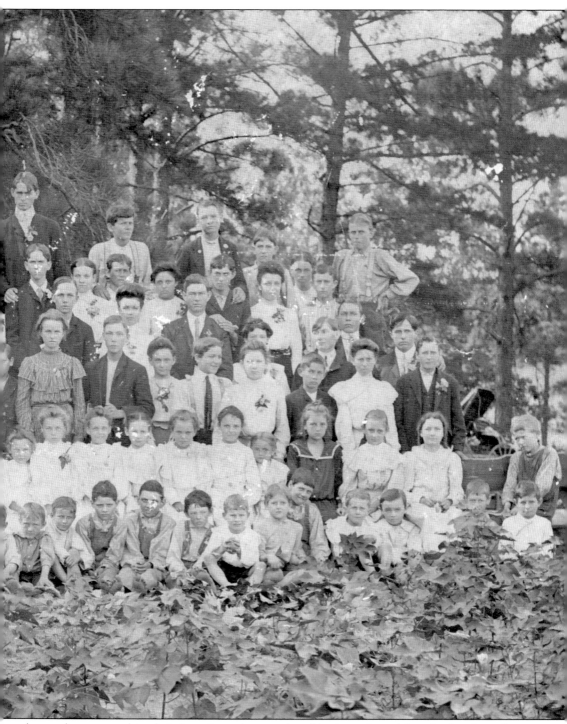

but each progressed in their learning using a series of basic readers. After the fourth reader, higher math and history followed. Among the family names associated with the school were Askew, Leach, Slaton, Spratlin, Stinchcomb, Whitlock, and Knowles. (Courtesy of Maggielene Knowles Robertson.)

Organized in 1869, the Line Creek Baptist Church erected its first building in 1875 on land donated by the Leach and Pollard families. The first Sunday school superintendent was F. M. Chandler, and the first treasurer was M. V. Whitlock. An organ was purchased in 1903. After several additions, the church was finally moved in 2004 to make way for commercial development; however, the cemetery is still there (behind present-day Best Buy), its stones engraved with names of area families' ancestors. (Courtesy of Barbara Huddleston Phillips.)

Bob Huddleston is pictured here around the time of his marriage to Emily Pope Huddleston in 1911. (Courtesy of Barbara Huddleston Phillips.)

Henry Brown, pictured at right, was the father of Harvey Brown, who had been a school bus driver in the early 1960s in Fayette County at a time when the drivers owned their own buses. Some of the buses were somewhat makeshift and were not the big yellow conveyances thought of today. (Photograph by W. D. Waters; courtesy of Maggielene Knowles Robertson.)

Around 1913 at the Brown home on Huddleston Road, this combination of Brown and Knowles families represents the melding by marriage typical of small populations in rural areas of the time. Of those who can be identified, there are Knowles, Brown, Spratlin, and Grantham families represented. Tall Arthur Brown, perhaps the man standing far right, and his brother were likely the men responsible for the hats at the edge of the porch roof. (Courtesy of Maggielene Knowles Robertson.)

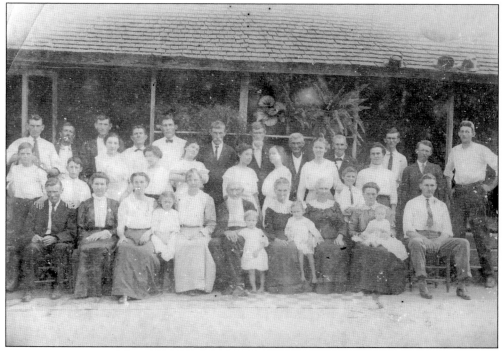

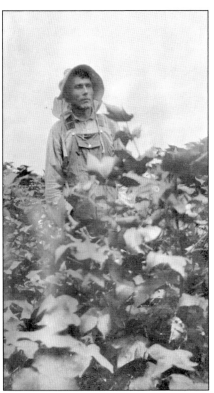

High cotton surrounds Andrew Knowles on his farm in 1920. Farmers prospered when cotton covered Shakerag fields, but the boll weevil killed the plants during the 1920s. Jobs became scarce, and people moved away. Fayette County's population decreased from 11,364 in 1920, to 8,665 in 1930, to 7,978 in 1950. Farmers raised cattle, catfish, and poultry and grew beans, corn, and other vegetables. In 1970, the county's population once again exceeded 11,300 and by 1980 reached 28,605. (Courtesy Maggielene Knowles Robertson.)

This 1970s cornfield existed in an area that became part of Peachtree City. Historically, corn was ground at various gristmills around Shakerag and provided hominy, grits, and meal for dinner tables. Corncobs could be hauled home to use as roughage feed for livestock, fuel in fireplaces, or, when decomposed, fertilizer for other crops. Once a ubiquitous crop, as the city increased in both population and area, cornfields disappeared.

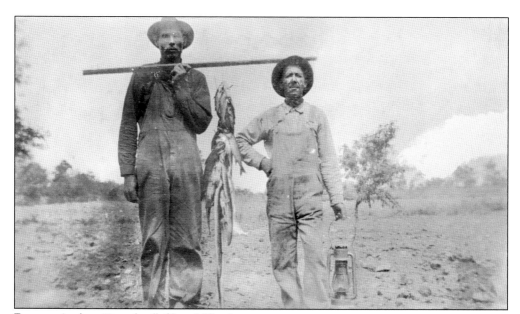

Farmers Andrew Knowles (left) and "Bee" Huddleston (right), on their way home from Line Creek, allow their catch of the day to be photographed for posterity. (Courtesy of Maggielene Knowles Robertson.)

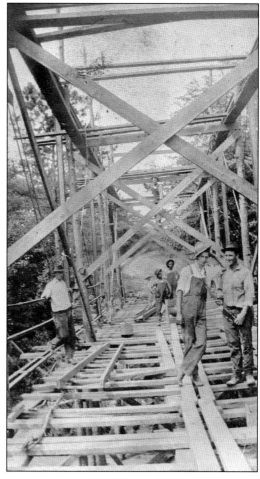

A bridge is constructed over Line Creek on Highway 54 around the dawn of the 20th century. Fayette County boundaries have changed over time, but the border at Line Creek remained and forms the western limits of today's Peachtree City. Near the bridge, at the Fayette-Coweta County line, Wynn's Mill operated with a huge waterwheel and water from Line Creek. Wheat and corn were ground there. In 1870, when G. W. Wynn was the owner, the miller earned a salary of $200 a year. Later the miller took a percentage of the corn as his pay. A store and a sawmill did not survive as long as the gristmill, which operated until the 1940s. (Courtesy of the Georgia Archives, Vanishing Georgia Collection, cow044.)

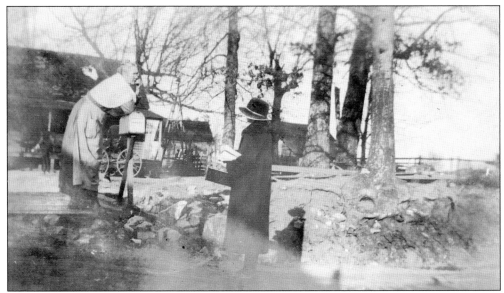

This wonderful country picture depicts the timeless tradition of women meeting to share their latest news. Note the horse and buggy in the background and the platform on which Fannie Brown Knowles must stand in order to check the contents of the mailbox. The mail was likely delivered by horse and buggy at this time in the late 1920s or early 1930s. (Courtesy of Maggielene Knowles Robertson.)

Oscar Phillips contracted with the post office in 1902 to operate the county's first rural mail route. "Star Routes" were awarded to the lowest bidders, who would deliver mail with "celerity, certainty, and security," designated by three stars (***). Oscar took the mail along Route One by horse and buggy to Starr's Mill, Shakerag, Aberdeen, and back to Fayetteville, driving his horse-drawn vehicle until he retired in 1932. (Courtesy of the Fayette County Historical Society.)

Located across the tracks on old Highway 74—today's Dividend Drive—David McWilliams rented a Clover store in 1918 with his father, Jim, and called it McWilliams and McWilliams. In a house close by, Dave and his wife, Berta, raised their children. In 1923, on land given him by Bob Huddleston, Dave built his own store near a short railroad spur coming off the main track in Clover. A sawmill stood nearby. Farmers bought supplies during spring and summer; when their crops came in, they paid their accounts. "You could flag the passenger train at Clover and go to Atlanta for 52 cents," Dave remembered in an interview for *This Week* in August 1974. (Right courtesy of Barbara Huddleston Phillips; below courtesy of Melvin Brown.)

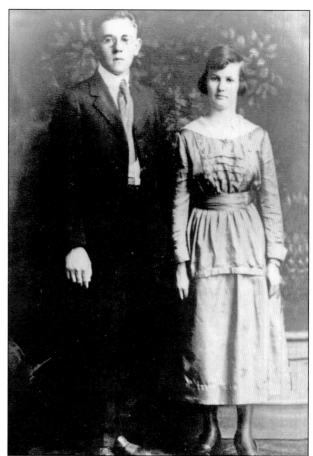

Oak Grove School was originally a one-room schoolhouse but expanded to two in 1915, before this photograph was made probably in the 1920s or 1930s. Located west of Robinson Road and south of Crosstown Road, the school was situated near the present-day Oak Grove Elementary School. Elizabeth McEachern Brown, known by her students as "Miss Lizzie," was among the teachers. "Ms. Maynard" Griggs Brown and Florene Huddleston Adams also had stints at Oak Grove School during their teaching careers. (Courtesy of the Fayette County Historical Society.)

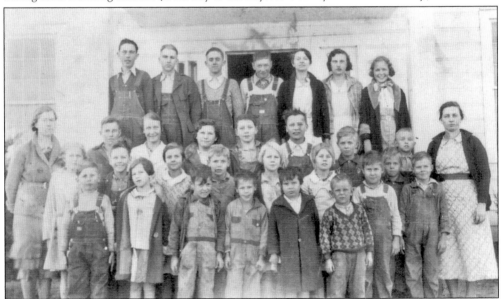

In 1927, Aberdeen trustees approved a $12,000 bond issue for a centrally located Line Creek school. It was the last of the two-room schoolhouses built in the area. The others were Oak Grove and Shakerag Schools. Holly Grove AME and Bethlehem Baptist Churches became schools during the week and taught children grades one through seven. In the 1950s, when county schools consolidated, the small learning centers became fewer and disappeared. (Courtesy of Maggielene Knowles Robertson.)

This sample report card, from the Aberdeen School in 1911, provided parents with the teacher's assessment of their child's performance in academics and deportment. Note that the subjects offered at the time reflected the interests and needs of the rural county in the early part of the last century. (Courtesy of Maggielene Knowles Robertson.)

Aberdeen SCHOOL.

Report of _Clara Williams_

For Month Ending _March_ 3 1911.

Attendance	8 5	History	
Punctuality	9 5	Arithmetic	9 4
Deportment	9 0	Nature Study	
Spelling	9 1	Agriculture	
Reading	8 3	Physiology	
Writing	9 4	Civil Government	
Geography	8 3		
Language Lessons			
Grammar	8 5	General average	8 8 9
Merits		Demerits	

Explanation: Maximum 100, Excellent 90 to 99, Fair 80 to 89, Passable 70 to 79, Unsatisfactory below 70.

To Patrons.

You are cordially invited to visit the school. Your presence will encourage the pupils to study. You are earnestly requested to examine this report carefully, and encourage your children in their studies by bestowing such praise as their standing deserves. See that they make 100 in deportment and punctuality.

Miss Bessie Davis Teacher.

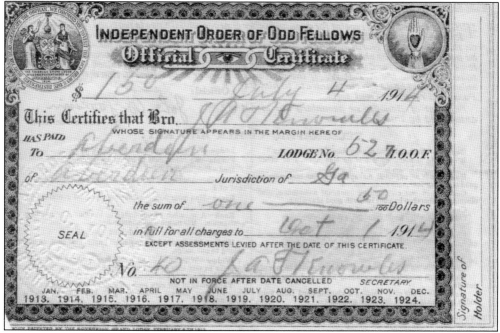

The Independent Order of Odd Fellows Aberdeen Lodge No. 527 of Fayette County was instituted on October 26, 1912, with 21 charter members and remained active until December 9, 1930, when the charter was surrendered to the Grand Lodge of Georgia. This receipt for Andrew Knowles's dues had a "telegraphic cipher and key" printed on the back. The cipher was a series of code words that enabled the lodge to communicate with other lodges in a sort of shorthand regarding club business. (Courtesy of Maggielene Knowles Robertson.)

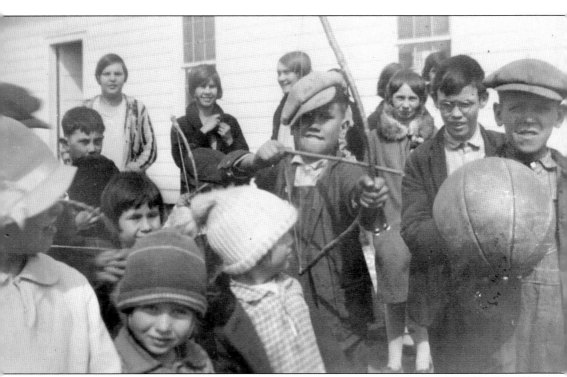

Hugh Huddleston, sporting a rakishly tilted cap, takes aim at the basketball held by his older cousin Jessie. These Aberdeen School students were taking time out of their studies to have their pictures snapped around 1930. Note the fox collar on the young girl in the background as well as the cloche hat on the girl in the foreground. Hugh's sister Florene, in the dark coat, watches from behind. (Courtesy of Maggielene Knowles Robertson.)

Three

ATLANTA'S NEW TOWN IN RURAL GEORGIA

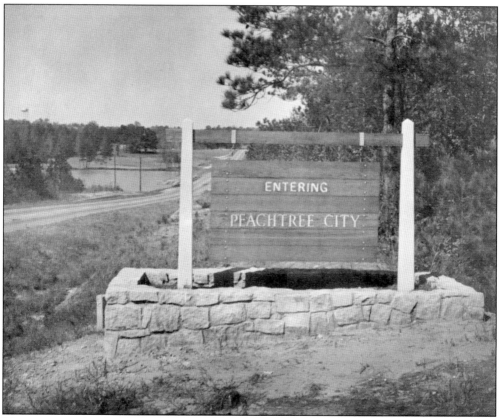

This sign erected in the 1960s along Highway 54 greeted those entering the new city. Lake Peachtree can be seen in the distance. The land to the right of the highway and beyond the sign was a Georgia state roadside park until the 1960s. The same land would much later hold the Sheraton Conference Center, which would change hands several times. (Courtesy of Joel H. Cowan.)

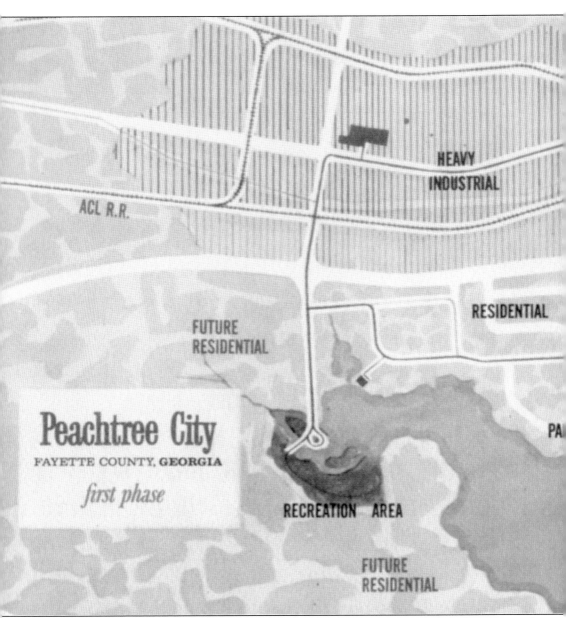

Peachtree City

FAYETTE COUNTY, GEORGIA

first phase

ACL R.R.

HEAVY INDUSTRIAL

RESIDENTIAL

FUTURE RESIDENTIAL

RECREATION AREA

FUTURE RESIDENTIAL

PA

Peachtree City was planned as a truly balanced community—integrating residential, commercial, light and heavy industry, and recreation areas. This "First Phase" of Peachtree City, as envisioned in 1961, was prepared by the Peachtree Corporation of Georgia, formed in 1959. The original investors in the planned city—the Fayette County Development Corporation—lacked the

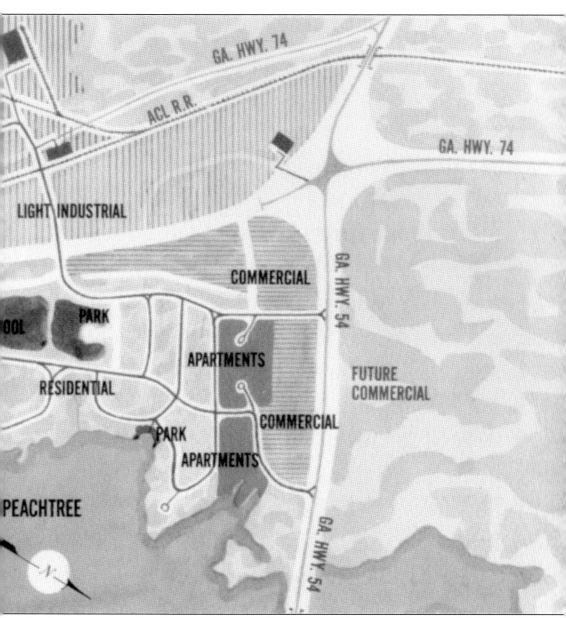

GA. HWY. 74

ACL R.R.

GA. HWY. 74

LIGHT INDUSTRIAL

COMMERCIAL

GA. HWY. 54

PARK

OOL

APARTMENTS

FUTURE
COMMERCIAL

RESIDENTIAL

PARK

COMMERCIAL

APARTMENTS

PEACHTREE

GA. HWY. 54

N

funding to continue, but Bessemer Securities Corporation of New York City provided financial backing, becoming the majority owner in the new Peachtree Corporation of Georgia. (Courtesy of Joel H. Cowan.)

Joel Cowan and his wife, Geri, moved into this house on Shakerag Hill in January 1959 after Joel's graduation from college the previous spring. Since Pete Knox hired Cowan in 1957 to build the new city, Cowan had been commuting to Fayette County from Atlanta. Built by Huie Bray, their home was a Knox prefabricated house and was located near Georgia Highway 54 where a Waffle House now stands. (Courtesy of Joel and Geri Cowan.)

Huie Bray, a Fayette County builder, presents Miriam Fulton, a real estate agent, with the first house built in newly chartered Peachtree City. In 1961, after she bought the residence, Miriam began working for the developers of Peachtree City, selling houses and lots. Ten years later, she opened her own Miriam Fulton Real Estate Office. In 1972, her son, Jim Fulton III, joined the business. (Courtesy of the Fayette County Historical Society.)

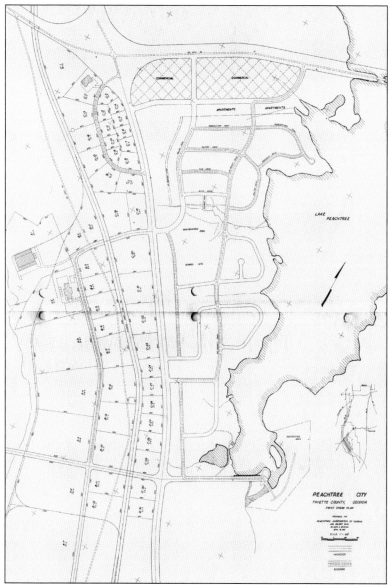

This 1961 drawing for the core of Peachtree City shows the plans for residential and commercial areas south of Highway 54 and west of Lake Peachtree. Joel Cowan laid out the first residential street in the fall of 1959 when he used a bulldozer to make an initial path for what became Hip Pocket Road. J. K. "Chip" Conner, a cousin of Joel's, assisted. When Chip pulled an inexpensive survey instrument out of his "hip pocket," the new street suddenly had a name. Conner became Peachtree city's third mayor in 1970. In this drawing, Hip Pocket Road is the first north/south street west of Lake Peachtree. The curved section of this street connecting to Highway 54 later became Willowbend Road. Lake Peachtree was the "jewel" and focus for early Peachtree City. This sketch shows the southern part of the lake. Residential development was envisioned for the western lake shore, but the eastern side would not be developed until later. The road (which became McIntosh Trail) initially led to the dam at the southern tip of Lake Peachtree, but it was the 1980s before this road was extended to connect to the sections of the city east of the dam. (Courtesy of Joel H. Cowan.)

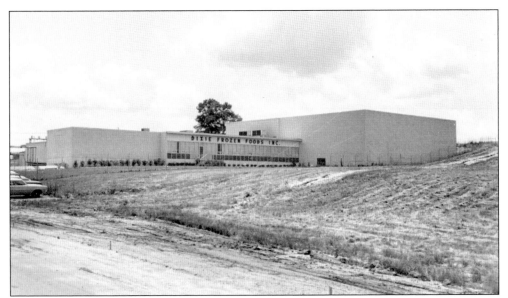

City leaders gave high priority to attracting industries to the new planned city. In 1960, Dixie Frozen Foods, employing 25 people, became the first company to locate in Peachtree City. To entice Dixie Frozen Foods to move to Peachtree City from the Little Five Points area of Atlanta, Cowan and the developers constructed this building and an elaborate septic system then leased the property to the company. (Courtesy of the Fayette County Historical Society.)

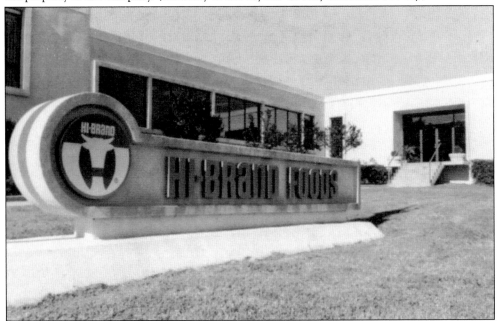

On November 7, 1968, because of rapid growth in regions beyond the South, Dixie Frozen Foods, Inc., changed its name to Hi-Brand Foods. The announcement came from the company chairman and president, V. C. Lassiter Jr., of Newnan. Several promotions were announced for Peachtree City's oldest company. Hi-Brand Foods was a pioneer in the processing and marketing of frozen portion-controlled meat products. When the company left Peachtree City, the land lay dormant for many years until it was purchased and developed into The Avenue, an upscale shopping area.

Floy Farr ran a small bank in Tyrone, which became the Fayette State Bank and moved to Peachtree City in 1965. It was located at the end of the municipal building (above). Anticipating the bank, Joel Cowan had the building ready, with a vault and drive-thru window. Peachtree City's first bank grew in tandem with the city, having to expand to a new bank building in Aberdeen Village with Farr in charge. The Fayette State Bank financed local homes and businesses, boosting Peachtree City's success.

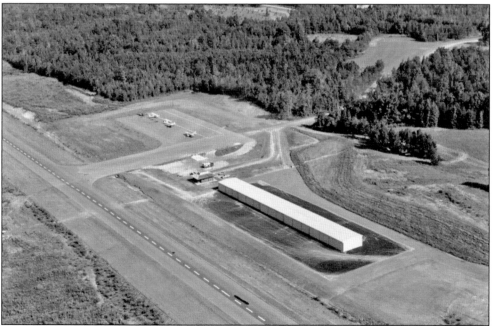

In 1966, Peachtree City applied for federal funds to construct Falcon Field. The Bessemer corporation donated 100 acres south of the town's industrial park, and by 1969, the airstrip, 50 feet wide and 3,000 feet long, was being constructed, paved, and lighted. Falcon Field, here viewed from the west, was founded by Joel Cowan.

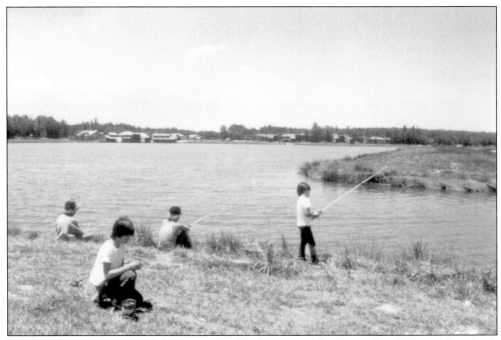

Lake Peachtree was a critical element in the development of Peachtree City. Early residents built their homes on or near the lake and enjoyed boating, fishing, and sometimes just the solitude found there. (Courtesy of Joel and Geri Cowan.)

Extremely cold winters are unusual in Peachtree City, but Lake Peachtree has been known to freeze on rare occasions. Here Mark Cowan and Joel Cowan Jr. test the ice with their friend and neighbor, Billy Cawthorne. (Courtesy of Joel and Geri Cowan.)

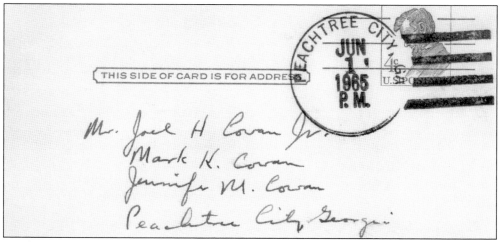

Mr. Joel H Cowan Jr.
Mark K. Cowan
Jennifer M. Cowan
Peachtree City Georgia

Peachtree City finally got its first post office in June 1965. Prior to that time, the residents of the city were served by rural routes out of the nearby towns of Fairburn, Fayetteville, and Senoia. Mayor Joel Cowan proudly noted the occasion with this postcard carrying the new postmark and addressed to his children, Joel Jr., Mark, and Jennifer. (Courtesy of Joel and Geri Cowan.)

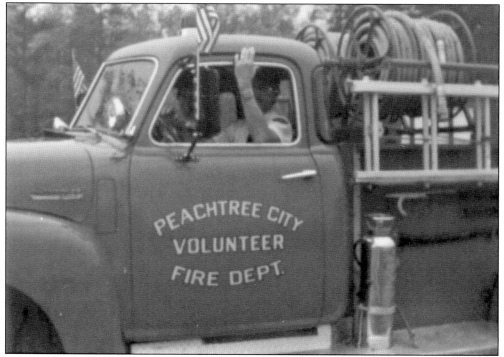

The Peachtree City Fire Department now boasts a well-trained team of over 100 firefighters, more than half volunteer personnel. However, the department was a small all-volunteer group in 1966, and the one fire truck, a 1949 Chevrolet 500-gallon-per-minute pumper, was refurbished by the first fire chief, Myron "Brother" Leach. The fire truck was housed at the Gulf service station until a fire house could be built in 1967. The early emergency calls were dispatched by Louise Leach, the chief's sister, who, for a time, received the calls in her home and then telephoned the volunteers. Louise was also the city's first "gossip columnist" on the staff of Jimmy Booth's newspaper *This Week*. (Courtesy of Paul Talbott, Peachtree City Fire Department.)

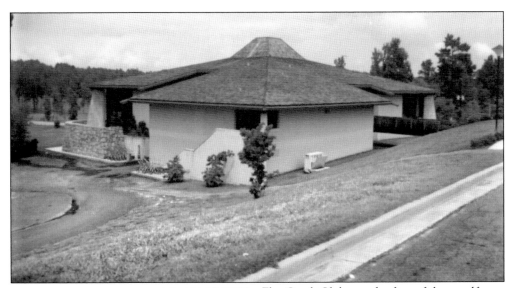

Flat Creek Club was the first of three golf courses to be built in Peachtree City. The Flat Creek course opened on Labor Day 1968. Shown here is the original clubhouse nearing completion. Many of the residents were avid golfers and often drove their golf carts from home to the course, beginning the use of golf carts as an alternative mode of transportation in Peachtree City. (Courtesy of the Fayette County Historical Society.)

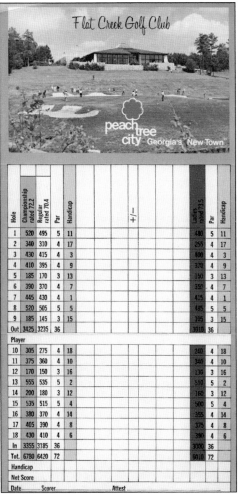

Hole	Championship rated 72.2	Regular rated 70.4	Par	Handicap		+/−		Ladies rated 73.5	Par	Handicap
1	520	495	5	11				480	5	11
2	340	310	4	17				255	4	17
3	430	415	4	3				400	4	3
4	410	395	4	9				370	4	9
5	185	170	3	13				150	3	13
6	390	370	4	7				352	4	7
7	445	430	4	1				415	4	1
8	520	505	5	5				485	5	5
9	185	145	3	15				105	3	15
Out	3425	3235	36					3010	36	
Player										
10	305	275	4	18				240	4	18
11	375	360	4	10				340	4	10
12	170	150	3	16				136	3	16
13	555	535	5	2				510	5	2
14	200	180	3	12				160	3	12
15	535	515	5	4				500	5	4
16	380	370	4	14				355	4	14
17	405	390	4	8				375	4	8
18	430	410	4	6				390	4	6
In	3355	3185	36					3000	36	
Tot.	6780	6420	72					6010	72	
Handicap										
Net Score										
Date	Scorer			Attest						

This early scorecard proudly identifies Peachtree City as Georgia's "New Town."

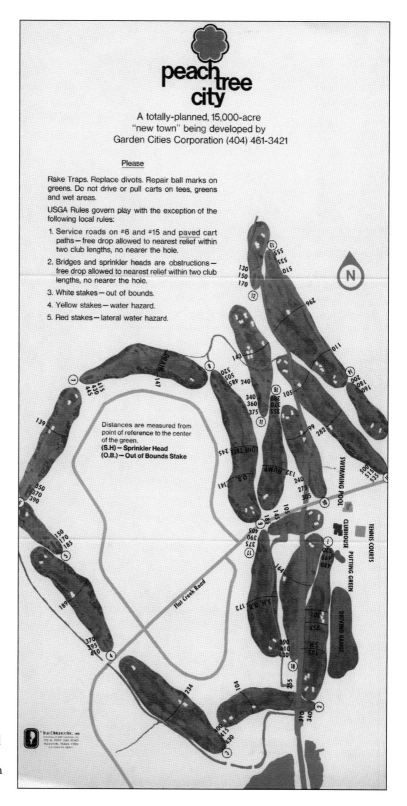

The top of the scorecard touts the city's totally planned 15,000 acres being developed by Garden Cities Corporation.

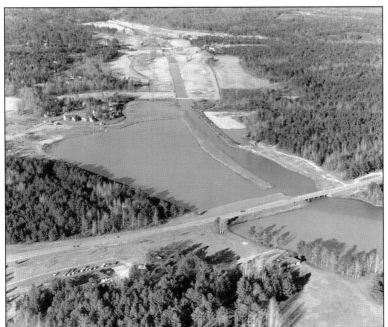

This 1960s aerial view shows the new city taking shape. Flat Creek Club Golf Course is under construction, and homes are being built on the north shore of Lake Peachtree. The small building on the western shore of the lake south of Georgia Highway 54 was constructed as a small motel to house businessmen visiting the new city and would later become the city's medical center.

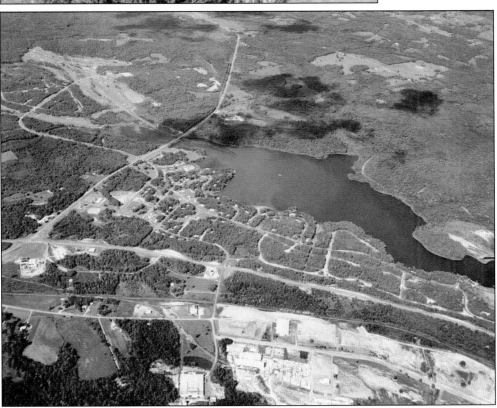

This late-1960s aerial view of Peachtree City shows the early residential area taking shape, the beginning of the new industries (at the bottom of the photograph), and the construction of Flat Creek golf course in the upper left.

50

Joel Cowan planned the first school for the city, built it with Bessemer funds in 1967, and leased it to the county for west Fayette County students in grades one through seven, just in time to comply with the court-ordered full integration of 1968. The columned building with a shingled hip roof had 30 classrooms and a 500-student capacity—primary students on one wing, older ones on the other, library in the center, and cafetorium/kitchen in the rear. Electricity was the sole power source with Coweta-Fayette EMC providing the service through wires buried underground. No unsightly utility poles could be seen. Timer devices controlled the heating and cooling systems. Said principal Lawrence Nash, "It sure is nice to come into a warm building every morning." In 1969, a total of 426 students attended the Peachtree City Elementary School. (Right courtesy of Peachtree City Elementary School; below courtesy of Joel Cowan History Room, Peachtree City Library.)

Rural Sparks

COWETA-FAYETTE ELECTRIC MEMBERSHIP CORPORATION
Newnan Georgia

Vol. XII April, 1969 No. 4

All Electric School . . . see pages 4 a[n]

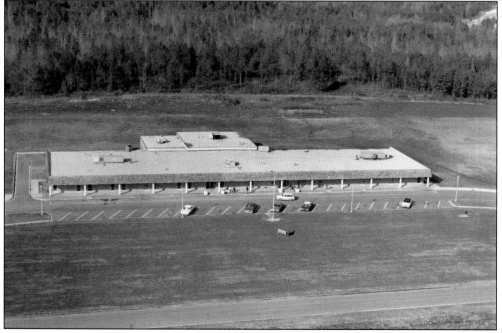

Mabie-Bell Schokbeton Corporation was one of the first industries to locate in Peachtree City. Opening in 1962, the company manufactured architectural pre-cast concrete products for commercial buildings. In 1969, the firm became Exposiac Industries and was responsible for providing the structural concrete framework for many projects in Atlanta as well as all over the eastern half of the United States. The old State Archives building, the Atlanta Merchandise Mart, and Colony Square were just a few of the projects in downtown Atlanta.

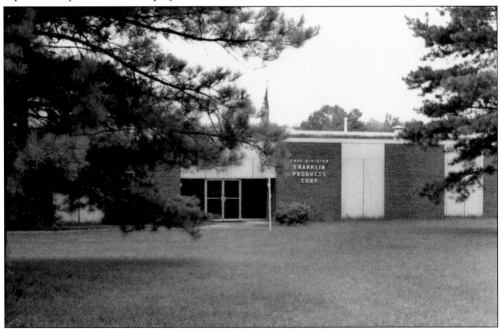

Attracting industry to Peachtree City was a critical goal of the city's founders. The industrial area, along Highway 74 South and near the railroad line, became the home to a growing number of companies in the 1960s and 1970s. Franklin Products, Inc., a manufacturer of restaurant equipment, moved to Peachtree City in 1967 and is pictured above in 1974.

Four

A City of Villages Takes Shape

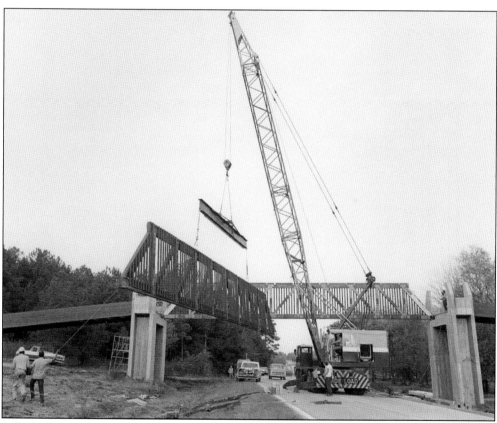

In 1972, Peachtree City built this wooden bridge over Highway 54 for pedestrians and bicyclists. With the passing of legislation in 1974 allowing golf carts on the city's streets, the bridge also provided residents easy golf cart access to the expanding shopping, parks, and other services around the city. When the highway was later four-laned, the bridge was replaced by a covered steel structure, maintaining the easy access to both sides of Highway 54 for those on foot, bicycle, or golf cart. (Photograph by Warren L. Bond Studios.)

The town's first church met in the city's municipal building. An Interdenominational Community Chapel, it formed in October 1964 with Rev. Cobb Ware serving as the first pastor. In May 1966, with 25 members, the Community Chapel became the Presbyterian Church of Peachtree City, and Rev. Donald Smith was pastor. Chip Conner, Joel Cowan, Luther Glass, Ralph Jones, and Bill Poe were the first elders. Congregants worshipped in private homes and administrative buildings until June 1971, when members erected the first Presbyterian church building (below) on Willowbend Road upon land donated by the developers. (Above courtesy of the Joel Cowan History Room; below courtesy of the Fayette County Historical Society.)

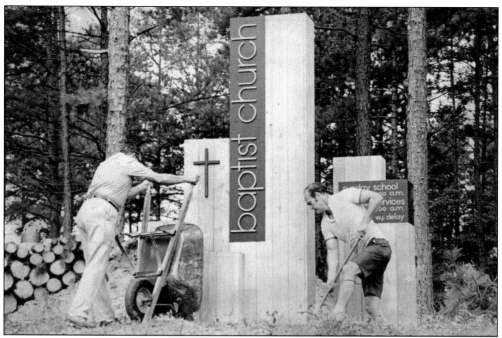

Local Baptists met at the Peachtree City Elementary School while planning to build a church in Peachtree City. Joel Cowan, president of Phipps Land Company, allocated 3.5 acres of land at Flat Creek Road (later reshaped and renamed Willowbend) and Hip Pocket Road for the sum of $1. On March 12, 1972, the congregation broke ground for the building, and on March 11, 1973, the first worship service was held in the Peachtree City First Baptist Church. Above, the church's first sign is erected by Jim Fulton (left) and Pastor William DeLay. (Above courtesy of First Baptist Church; below courtesy of the Joel Cowan History Room.)

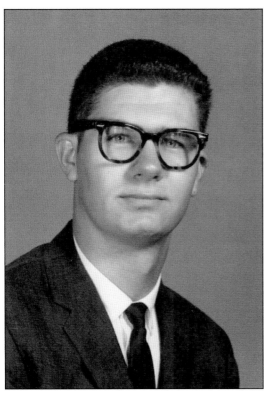

Henry C. Drake was born in Newnan in 1936 and graduated from Newnan High School, the University of Georgia, and the University of Tennessee School of Medicine, where this picture was taken. After practicing in Newnan and Macon for a few years, he came to Peachtree City in 1971. In 1979, Drake donated land behind his clinic to the city for the youth soccer league. They named it Drake Field. Due to health problems, Dr. Drake retired in his 40s, first to Colorado and then to South Carolina, where he died in 1998. (Courtesy of W. Homer Drake Jr.)

This building situated near Lake Peachtree, originally constructed as a small motel for visiting businessmen, later became the city's first medical facility. The Peachtree Medical Clinic opened here in 1971 with the arrival of the first doctors in the city, Dr. Henry Drake and Dr. Mildred Keene.

J. V. Rowley (left), of Bracknell Development Corporation, accompanies Joel Cowan (center) and Atlanta mayor Sam Massell (right) on a tour of British new towns in April 1972. In the British system, London is surrounded by a miles-wide greenbelt through which no development is permitted, restricting the possibility of further city sprawl. Outside the greenbelt, 20 or so satellite towns exist. These towns are self-contained, but parking lots at the train stations of these outlying "garden cities" allow those who work in London to commute by rapid transit. Also on the tour were Charles Barton, Harvey Mathis, and James E. Cushman, who wanted to learn what could be useful for the future development of the city of Atlanta. (Courtesy of Joel H. Cowan.)

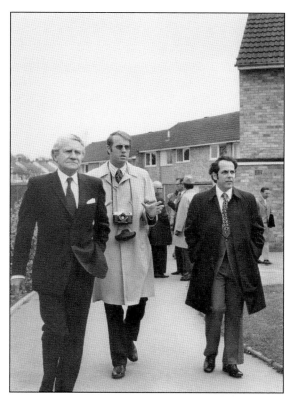

The city's first actual fire station was built in 1967 on Paschall Road. First called Station 1, it was later dubbed Station 81 and then later still dedicated to the town's first fire chief, Myron "Brother" Leach, becoming Leach Station. This building was replaced in 2001 by a much larger structure also housing the department's training facility.

In 1953, the McWilliams moved their Clover store 2 miles north to Highway 54, across from today's Planterra subdivision. Dave and Berta opened the shop six days a week and stocked groceries, fertilizer, plant seed, hardware, farming tools, shoes, clothes, stovepipes, well pulleys, and horse blinders. Dave added the prices of the items to be purchased in his head, and visitors never argued with his figures. (Courtesy of Melvin Brown.)

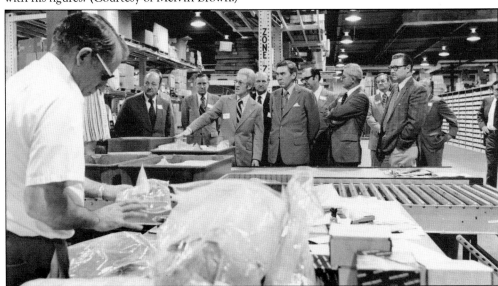

In 1972, the second largest producer of general business equipment, National Cash Register Company, became the 21st industry to locate in Peachtree City, bringing its Worldwide Service Parts Center here. The plant opened in the fall of 1973 with 250 employees and was for many years the county's largest single taxpayer. The company sustained itself through a number of industry shake-ups—including being absorbed by AT&T for a few years before it was spun off into a "new" NCR again. Warehouse distribution manager George Sauer (pointing) leads a tour of the facility, which included Bob Bivens of Garden Cities (with glasses near center of photograph).

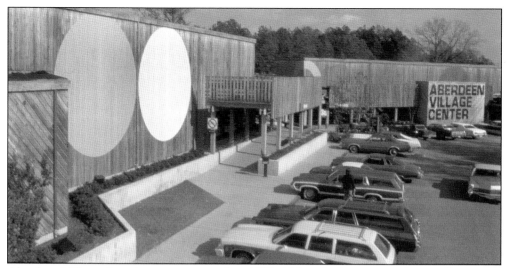

Aberdeen Village shopping center opened in 1973. Although there were other small stores in the city, Peachtree City now had its first retail center. Early occupants included the Aberdeen Barber Shop, Fayette State Bank, Jim Hudson's grocery, Thompson Pharmacy, and men's and women's clothing shops. The center would change and grow during the coming years with the addition of a variety of retail stores and businesses, a Visitor's Center, and Peachtree City's first library. The center's most popular tenant, Partner's Pizza II, arrived in 1977. (Courtesy Jim and Marilyn Royal.)

Ben and Pat Davis's Spare Time Shop was one early indicator of the city's love of all things sporting. They sold athletic gear, bicycles, tricycles, wagons, scale models, and many leisure and hobby supplies.

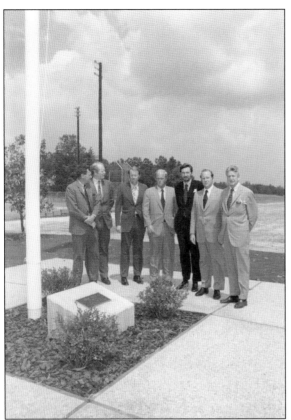

In July 1973, directors of Phipps Land Company visit the memorial marker at Riley Field. James F. Riley Jr.'s name was on the early conceptualization plan as president of the Peachtree Corporation of Georgia, with Joel H. Cowan as manager. Riley was also a vice president of Bessemer Securities Corporation. He stayed at Shakerag Lodge often when visiting Peachtree City. Pictured from left to right are J. E. Phipps, J. Gordon Douglas III, Joel H. Cowan, Ogden M. Phipps, Frederick E. Guest, Bruce C. Farrell, and T. W. Keesee Jr.

Riley Field became home for Peachtree City youth baseball and softball teams for men, women, and girls, as well as rugby teams.

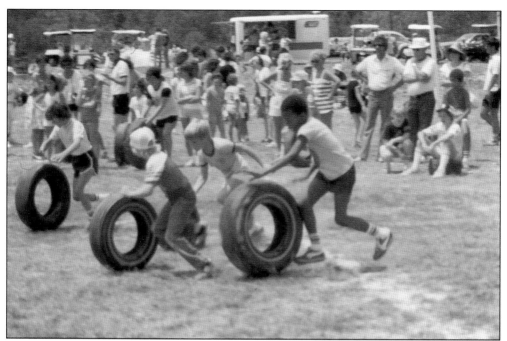

Kids and adults alike took their turns at the tire-rolling contest held at Riley Field during Fourth of July festivities in 1973.

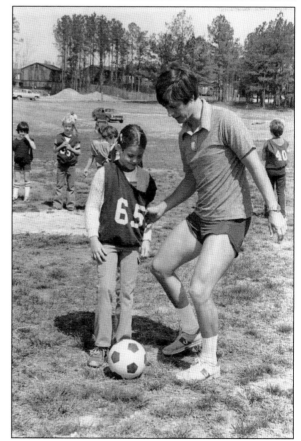

As in other communities, soccer became a popular sport in Peachtree City in the 1970s, and leagues formed to attract players of all ages. Here is coach Dick Cassell conducting a soccer clinic at Glenloch Recreation Center and giving some special instructions to Lea Davis, age 8.

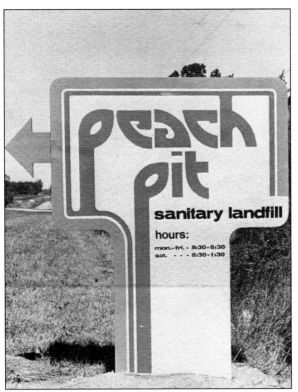

In March 1973, Phipps Land Company opened Peach Pit, Peachtree City's first sanitary landfill, located off Highway 74, north of Highway 54. The Peach Pit was privately owned and operated by Phipps for the benefit of Peachtree City residents. However, after a few short years, it had reached its capacity and closed.

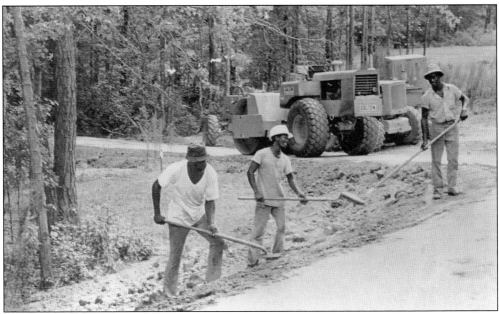

Construction began in September 1974 on a cart path along Bridlepath Lane, running from Glenloch Recreation Center to Piney Knoll subdivision in Glenloch Village. Shown here are Arthur Maddox, Melvin Stenson, and William Ray of Ray and Sons, Contractors, who employed both hand tools and heavy equipment to get the work done. Along with three other links, this one would complete the northern half of the Glenloch Village cart path system.

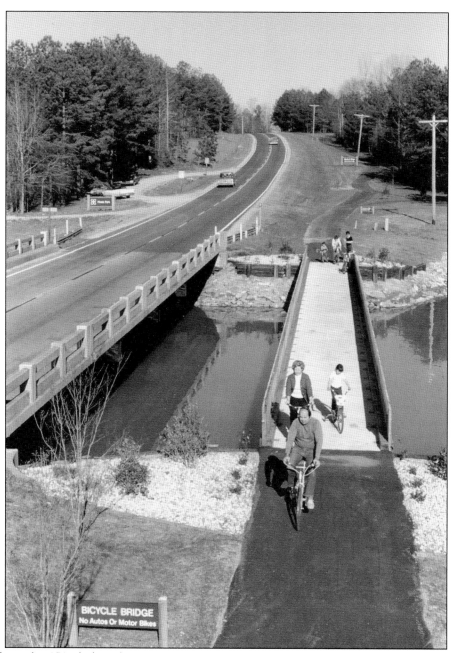

BICYCLE BRIDGE
No Autos Or Motor Bikes

In the early 1970s, kids and parents alike enjoyed riding their bikes on this path spanning Lake Peachtree. Bicycle paths would ultimately become multiuse paths and the city's secondary road system. Parents began using the paths to golf-cart children to school, and golfers drove to and from the club at Flat Creek. The trend took hold. In 1974, the Georgia Legislature approved golf cart travel over Peachtree City streets. As new villages emerged, the cart path system expanded to connect neighborhoods, shops, parks, and city buildings. Bridges and tunnels allow navigation around busy roadways, whether carting, biking, running, or walking. Over 90 miles of twisting, rolling, tree-shaded paths exist, with nature—birdsong, clear skies, and the lift of a breeze—always nearby.

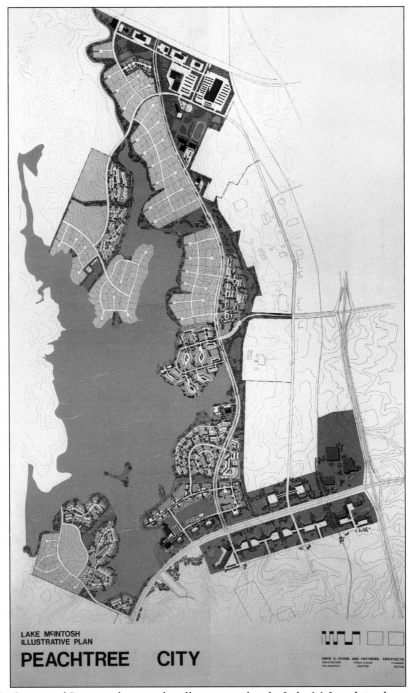

LAKE MCINTOSH
ILLUSTRATIVE PLAN

PEACHTREE CITY

DAVID A. CRANE AND PARTNERS, ARCHITECTS
ARCHITECTURE URBAN DESIGN PLANNING
PHILADELPHIA HOUSTON BOSTON

David A. Crane and Partners drew up this illustrative plan for Lake McIntosh in the early 1970s as a supplement to the Peachtree City Plan Review that had been done by Richard Browne Associates. However, an agreement among the varying interests was elusive. Two counties, two cities, a variety of landowners, and developers all had opposing viewpoints on the benefits and costs of the project. In 2007, more than 30 years later, the lake project was again revived and Lake McIntosh may at last come to fruition.

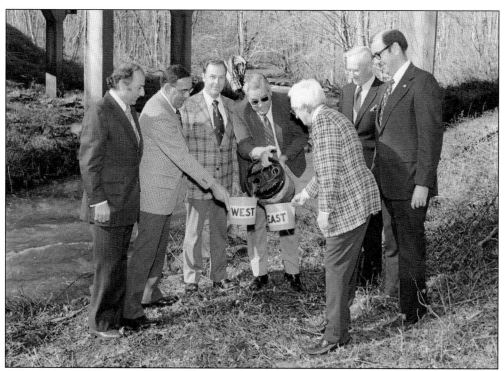

Officials from both sides of Line Creek participated in a "water-sharing ceremony" in January 1976. At issue was how much water could Coweta County and the city of Newnan, lying west of the creek, draw and how much could Fayette County (generally) and Peachtree City (specifically) draw. The dispute had dragged on for several years, and one man leaving the ceremony quipped that "with the money we spent on lawyers we could have built another river." Holding the "West" bucket is Newnan mayor Joe Norman. Holding the "East" bucket is Peachtree City mayor Howard Morgan. (Photograph by Warren L. Bond Studios.)

During the summer of 1975, Garden Cities inked a deal with Cohn Communities and Fayette State Bank for a $3.3-million home building program. Pictured are, from left to right, (first row) Margaret Boyd, Floy Farr, unidentified Cohn Communities representative, and Bob Bevins; (second row) Mal Sherman and unidentified.

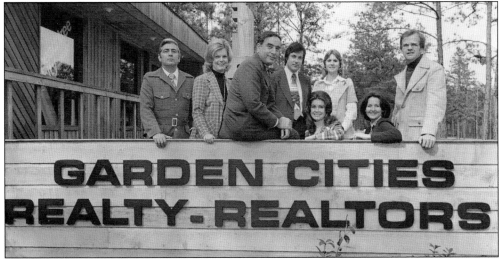

Mal Sherman, broker for Garden Cities Realty, poses for a publicity shot in front of the Peachtree City Information Center in the early 1970s. Shown here are, from left to right, Bill Warren, Signe Potts, Sherman, Richard McCarl, Carol Ottman, Debbie Mask, Angie McCarl, and Maurice Brown. Garden Cities was working hard to sell families on the amenities provided by the developers while others worked to lure industries to the area. The McCarls were also active in the local Peachtree City Theater Group directed by Geri Cowan. (Photograph by Warren L. Bond Studios.)

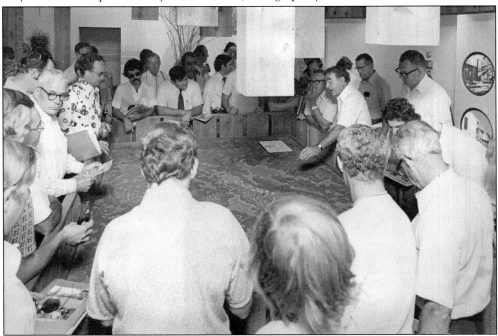

Attendees of the National Homebuilders Convention, held in Atlanta in July 1975, listen as Mal Sherman explains the topographic map in the city's Information Center. The map was constructed by Models Unlimited of Atlanta and was a focal point for those seeking to promote the city's well-planned "new town" concept. The Information Center, which opened next to Aberdeen Village Center in August 1974, held colorful displays prepared by the Robert K. Price Company with photography by Warren L. Bond Studios. (Photograph by Warren L. Bond Studios.)

In January 1976, Garden Cities Corporation president Bob Bivens (right) travelled to Dallas to accept the Better Homes and Gardens Grand Award for "Sensible Growth Design and Planning" from publisher Jack Rehm (left). The magazine cosponsored the competition with the National Association of Homebuilders. The award was one of only six issued that year among the 137 entries.

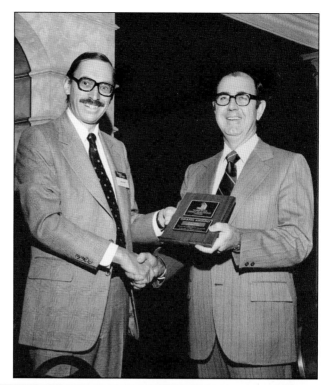

While others endeavored to get the word out nationally, Jimmy Booth, publisher of *This Week* newspaper, promoted the town locally and gave voice to the affairs of the town's citizenry. A master of marketing, Jimmy Booth promoted his new newspaper with T-shirts and coffee mugs. The coffee mug touted an image of the headline "PTC 'Best informed' community of 3,800." *This Week* helped to promote Peachtree City's identity as a "new town."

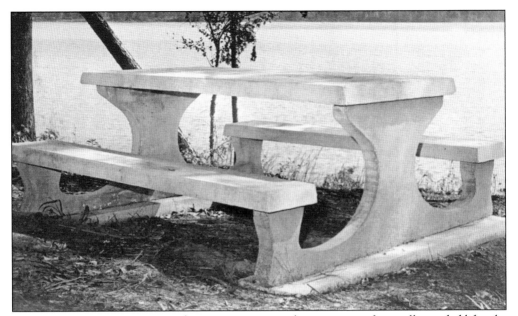

Garden Cities Corporation wanted to create recreational opportunities for a well-rounded lifestyle. Of several picnic tables placed around town in 1975 for city residents, this one still stands near Lake Peachtree. Another was in the old state park on the north side of Highway 54. The park (see page 63) would be replaced by the Sheraton Conference Center (now the Wyndham).

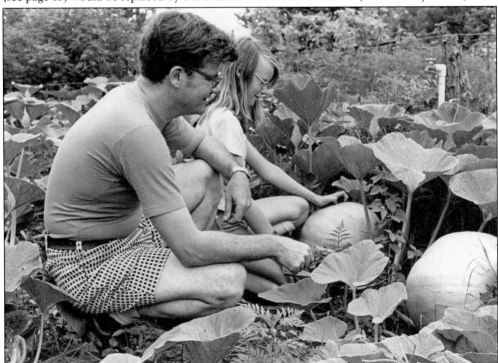

Community Gardens began in the spring of 1975 with 43 plots on Garden Cities property on Highway 54 East. It was such a success that the number of plots increased to 76 the following year. Shown here are Bob Neff and his daughter.

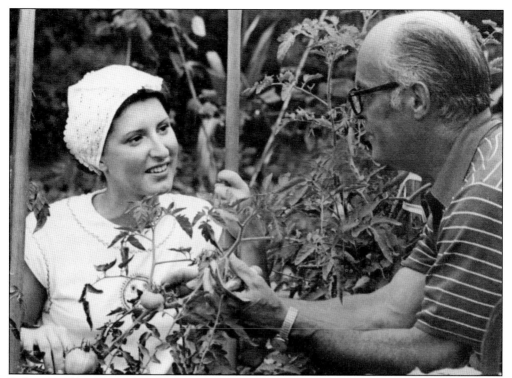

Robert Mudd and Carol Talbott talk over the tomatoes in the community garden. Bob, who had retired from NCR after 36 years with that company, was the program administrator for the gardens.

Glenloch Stables opened in 1972 in the village of Glenloch, where some street names recall the equine theme: Bridal Path Lane, Paddock Trail, and Morgan's Turn. Alongside the barn stood a white-fenced show ring surrounded by grassy pastures. Lee Massey was the owner/supervisor and taught riding classes. Today soccer fields cover the land that once stabled horses. (Photograph by Warren L. Bond Studios.)

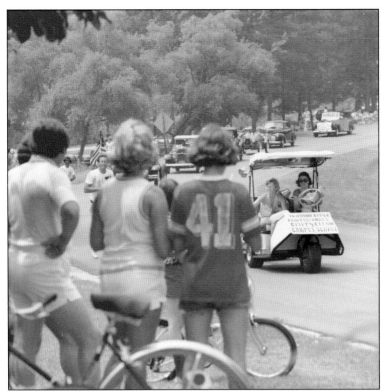

In 1975, the "Happiness Is . . ." Independence Day celebration included a parade, which started at noon and wound its way to Riley Field where a flag-raising ceremony took place. The parade included floats, antique cars, horses, decorated bicycles, and fire and rescue vehicles. Over the years, the Fourth of July festivities have been a defining feature of the patriotic spirit of the town.

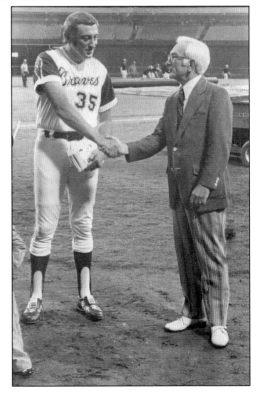

Phil Niekro, Atlanta Braves pitcher and future member of the Baseball Hall of Fame, made Peachtree City his home for a time. Mayor Howard Morgan welcomed the Niekro family to the city in September 1975 during the joint Phil Niekro/Peachtree City Night at Atlanta–Fulton County Stadium. Morgan presented the Niekro family with a new golf cart to use on Peachtree City's cart paths, which at the time totaled 10 miles. (Courtesy of Dolly Morgan.)

In addition to the annual pumpkin sales by the fire department, the Halloween celebrations of yesteryear also included the Glenloch Spook House, the House's Spook House, and Goblin Hollow on Shakerag Knoll, where volunteer ghouls would be sure to give a good scare. All in good fun, these and other October festivals helped to give the community plenty of opportunities for play.

Participants share the good times at the annual Yule Log Festival. Started in 1972, the event brought together many of the city's residents for singing, fellowship, and the warmth of the fire while awaiting Santa's arrival. The first year, the event was held in front of the medical center at the edge of Lake Peachtree. By the third year, approximately 800 people attended the event when it was held at Aberdeen Village Center.

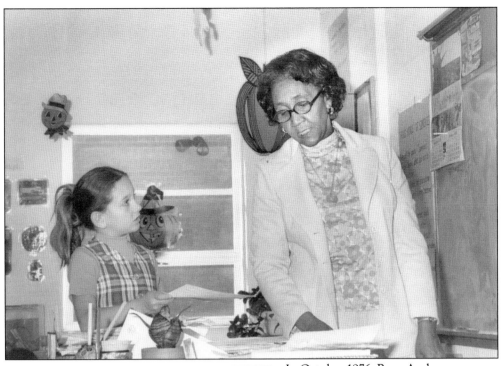

In October 1976, Rosa Anderson was chosen by the Fayette County Teachers Association as Teacher of the Year for the statewide competition sponsored by the Georgia Association of Educators. Anderson taught fourth grade at Peachtree City Elementary School that year. She is pictured with student Wendy Smith. (Courtesy of Fayette County Historical Society.)

A student and her teacher stand proudly in front of the Huddleston Hounds banner. Peachtree City Elementary and Huddleston Elementary were the first two primary schools to be built in Peachtree City.

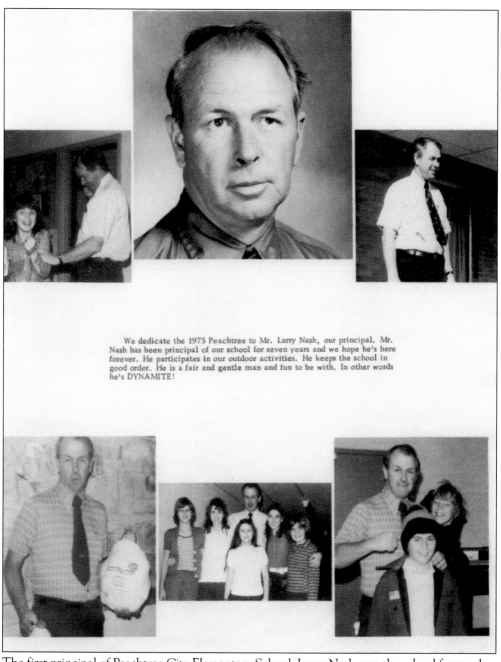

We dedicate the 1975 Peachtree to Mr. Larry Nash, our principal. Mr. Nash has been principal of our school for seven years and we hope he's here forever. He participates in our outdoor activities. He keeps the school in good order. He is a fair and gentle man and fun to be with. In other words he's DYNAMITE!

The first principal of Peachtree City Elementary School, Larry Nash, ran the school for nearly a decade. In 1975, the students dedicated the yearbook—*Peachtree*—to him. "Mr. Nash has been principal of our school for seven years and we hope he's here forever. He is a fair and gentle man and fun to be with," said the inscription. His wife, Annette Nash, also well loved, served as school librarian. In her 10th year at Peachtree City Elementary School, the students dedicated the yearbook to her. (Courtesy of Peachtree City Elementary School.)

73

In July 1975, the directors of the McIntosh Trail Arts Council announced that they would be the contractors for the building of an outdoor amphitheater in which to stage a historical drama concerning the Creek Indians in Georgia. A topographical survey was underway, and roads and building sites were cleared through the tall pines near the Flat Creek Nature Area. A $100,000 grant from the American Revolution Bicentennial Commission allowed construction to begin in October, under the supervision of Reuben Brown. Architect Barry Moore of Houston submitted preliminary plans for the theater. In December 1975, David Weiss, professor of drama at the University of Virginia, was selected as technical consultant to *The McIntosh Trail*, the outdoor drama scheduled to open in Peachtree City in June 1976. Weiss would be responsible for stage design, sound, and lights.

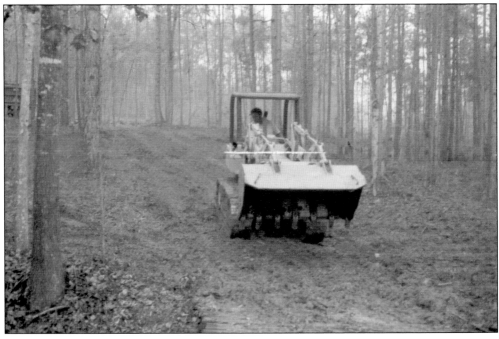

Five

GROWTH OF A NEW TOWN

One hundred fifty-eight Peachtree Citians surprised Floy Farr (second from right) at the Flat Creek Club in December 1975. Farr, expecting to attend a local builders meeting, was the guest of honor at "Peachtree City Appreciation Night for Floy Farr." An invocation by Don Smith, of the First Presbyterian Church, called Floy "an outstanding humanitarian, a conscientious citizen, a solid churchman and a friend to all." Brownie Jones (front left), wife of former mayor Ralph Jones, led a choir singing Christmas carols and "For He's a Jolly Good Fellow." Mal Sherman (not pictured) of Garden Cities emceed the event organized by the business community. He introduced the man of the hour with "much of what we are and what we will become is because of him." Also pictured are Hoke Archer, facing Farr; Alline Southern, center; and Bob Southern, far right. Herb and Shirley Frady are in the background.

In April 1976, these gentlemen attended the Sixth Congressional District Bicentennial Meeting in Newnan to discuss activities commemorating 200 years of the nation's history. From left to right, they are Dann Jackson of the McIntosh Trail Arts Council; James A. Beavers, vice chairman for the district; Bob Thorburn, district chairman; and Peachtree City mayor Howard A. Morgan.

Pictured here are Carolyn Cary, Chief "Dode" McIntosh of the Lower Creek Indians (center), and Robert K. Price Sr., president of the McIntosh Trail Arts Council, Inc., and chairman of the Fayette County Bicentennial Commission. When the amphitheater and the drama were conceived, Peachtree City was a budding city of 3,800 people, some of whom would perform onstage as extras to the professional troupe. (Courtesy of Carolyn Cary.)

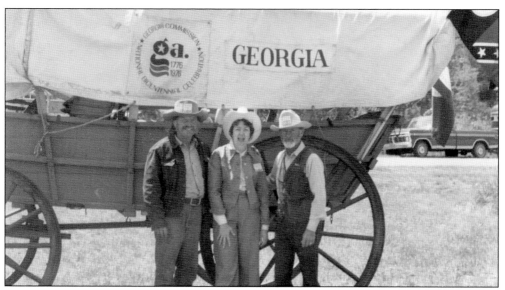

On its way to Valley Forge to converge on July 4, 1976, with wagons from across the United States of America, the Georgia portion of the Bicentennial Wagon Train stopped in Peachtree City. They camped at Glenloch Stables and held an evening show for over 1,000 people at Picnic Park on Lake Peachtree. Fayette County historian Carolyn Cary emceed the program, and Robert Price, local chairman of the Bicentennial Committee, offered the welcome. Scrolls of Rededication, signed and delivered by county officials, were presented by Cary to Georgia wagon master Frank Rickman. The wagon train troupe performed a "Transcontinental Bicentennial Show." John Braselton led the Sunshine Singers from Fayette County High, and the 4-H Swingers performed a square dance. The picture above includes Frank Rickman (left), Carolyn Cary (center), and national wagon master Harry Lee (right). (Courtesy of the Fayette County Historical Society.)

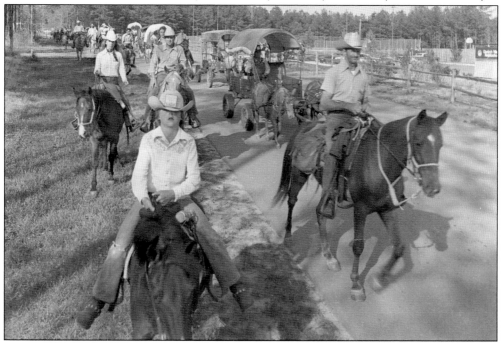

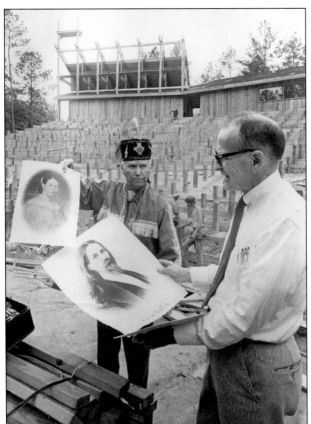

Kermit Hunter (right), author of *The McIntosh Trail*, and Chief W. E. "Dode" McIntosh (left), the great-grandson of Chief William McIntosh, look at pictures of William McIntosh's son and daughter against the backdrop of the unfinished amphitheater. Hunter had written *Unto These Hills* and *Trail of Tears* before he was called upon to write the script for *The McIntosh Trail*. (Courtesy of Glen Allen.)

No source can be found for this unattributed map, which was printed in the program for *The McIntosh Trail* outdoor drama. It may be a modern map rendered in an old-fashioned way. But regardless of its true origin, it does trace the general path of the trail used by the Muscogee (also known as Creek) Nation and, notably, Chief William McIntosh, whose properties the trail connected.

The McIntosh Trail

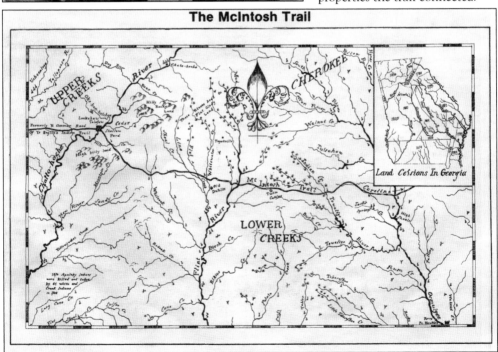

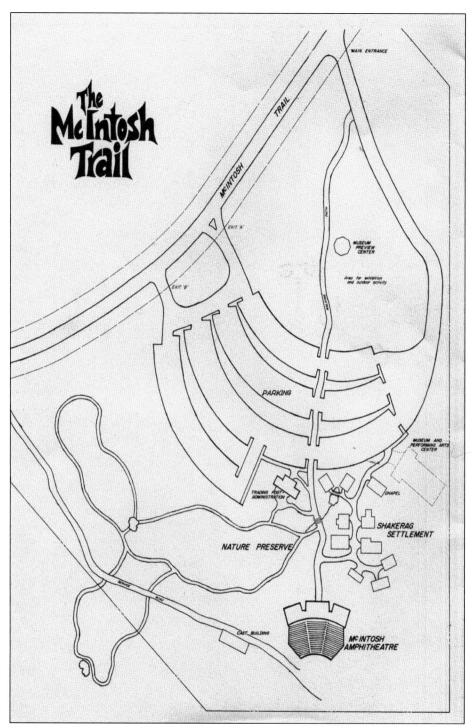

The McIntosh Trail

MAIN ENTRANCE

McINTOSH TRAIL

EXIT 'A'

EXIT 'B'

MUSEUM PREVIEW CENTER

Area for exhibition and outdoor activity

PARKING

MUSEUM AND PERFORMING ARTS CENTER

TRADING POST ADMINISTRATION

CHAPEL

SHAKERAG SETTLEMENT

NATURE PRESERVE

BOONE ROAD

CAST BUILDING

McINTOSH AMPHITHEATRE

Published in the 1976 program for *The McIntosh Trail* outdoor drama, this map shows the hoped-for McIntosh Complex, including the Shakerag Settlement and a proposed museum and performing arts center. Sadly, these plans never came to fruition, and the BMX track would, in later years, occupy the area that had been envisioned as an arts center.

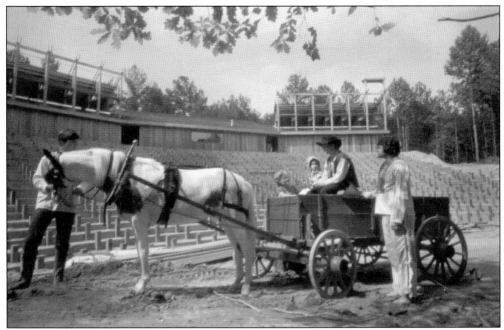

In advance of the drama at the McIntosh Amphitheatre, a horse-drawn wagon visited the arena with attendants dressed for a bygone era. Construction was still in progress and the seating not yet in place for the coming production.

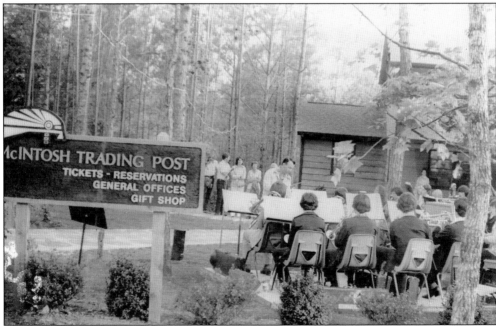

In June 1976, prior to "Fayette County Night" at *The McIntosh Trail* historical drama, the Fayette County High School Band, directed by Ben Westberry, performed at the McIntosh Trail Arts Complex. The Trading Post gift shop carried Georgia craftspersons' wares, including ceramics by Peachtree City folks Delores Hestalin, Otie Miles, and Sylvia Mathews, as well as postcards, souvenir coffee mugs, and children's books by Fayette County author Robert Burch.

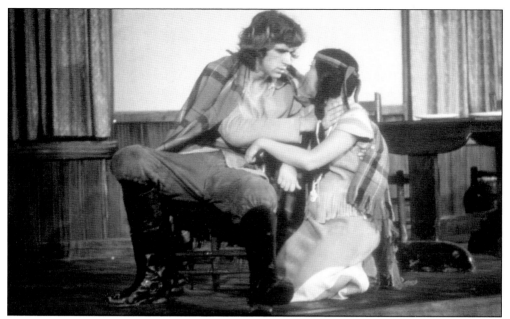

The McIntosh Trail is the story of William McIntosh, chief of the Lower Creek Indians, whose struggle as half Scotsman and half Native American to bring two worlds together resulted in his tragic murder. Here are scenes from the play. Onstage above is Malcolm MacKinnon in the role of McIntosh and Tish Merrill as his wife, Suzanna. The pageant dramatized the cultural similarities between the Scots and the Creek Indians: pride in heritage, loyalty to family, love of dance and music, colorful dress, and strenuous competitive games. Marvin Gordon directed and choreographed the production, portraying authentic dances of the Creek Indians. Frank Lewin wrote the music, which included traditional Creek music, Scottish bagpipes, and popular melodies from the early 19th century. Jack Kesler, a University of Georgia drama professor, designed the costumes.

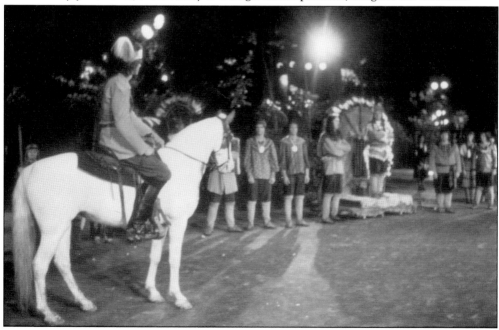

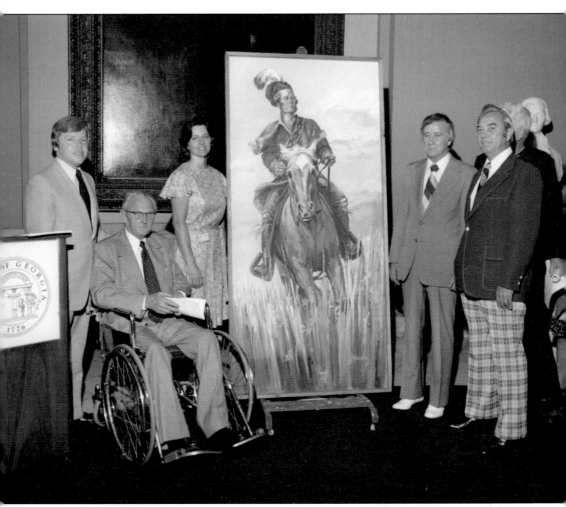

The portrait of Chief William McIntosh painted by artist Jo Ellen Eyster Macon and used in the program for *The McIntosh Trail* was presented to the State of Georgia at the capitol in 1977. Shown from left to right are Georgia state senator Ed Johnson, Secretary of State Ben W. Fortson Jr., Macon, Fayette State Bank president W. Floy Farr, and state representative John Mostiler. (Photograph by Jessie Sampley.)

As part of the country's bicentennial festivities, citizens buried a time capsule to be opened on July 4 of the future 300th anniversary celebration in 2076. Tom Haynes of Westminster Memorial Gardens assisted by providing both a vault and expertise in packing the treasures appropriately for the long haul. Buried originally at the site of the old Leach Fire Station on Paschal Road, the capsule was relocated in 2001 when the Leach station was moved and enlarged.

Albert Coleman conducted the Atlanta Pops Orchestra at the McIntosh Amphitheater for several years running. In September 1982, he led the musicians in a performance of selections by George Gershwin, Henry Mancini, Vincent Youmans, and Leon Delibes. The Pops appearances were supported by local businesses and residents.

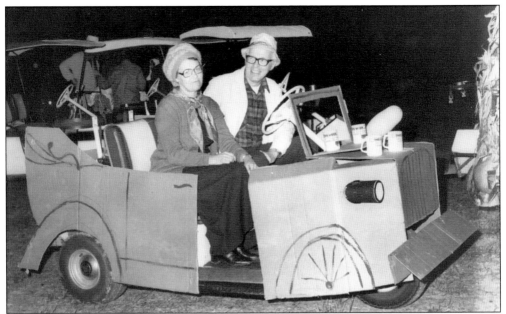

In 1976, Jackie and Howard Craven won the "Best Decorated" prize at the third annual Great Peachtree City Golf Cart Rally. Decorations and costumes had a Halloween theme. Other winners were John and Cynthia Johnson, Ellie and Ike Fenton, and Jan and Dennis Hail. The Devil May Care Musicians, led by John Hallberg, provided music for a sing-along at Huddleston Pond following the rally, where the Peachtree City Jaycees prepared a cookout.

Employees of the Fayette State Bank gather for a Christmas greeting with Santa outside the bank at Aberdeen Village Center. Shown are, from left to right, (first row) Sandra Gosdin, three unidentified, Valerie Southern, Vicky ?, Barbara Pittman, Inell McElwaney, Vickie Johnson, and Jeanne Barnett; (second row) Ann Olvey, unidentified, Ann Crozier, Kathe McGee, unidentified, Elizabeth Steed, Annie Connally, Connie Brown, Margaret Boyd, and Susie Stockstill; (third row) Tony Brown, Jerry Crozier, Floy Farr, and Richard Garcia.

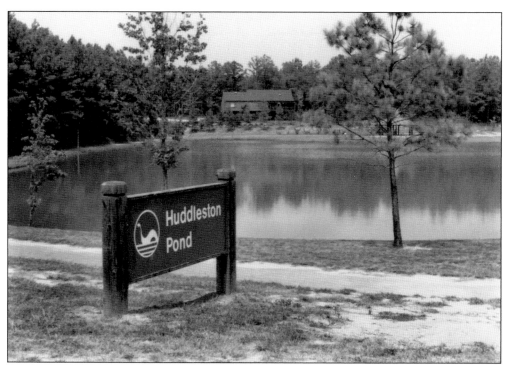

In 1976, Garden Cities Corporation opened two subdivisions—Windgate Ridge and the Overlook—in the Huddleston Pond area of Glenloch Village. Many lots overlooked the pond. Lot sizes ranged from one-third to three-quarters of an acre and prices of houses from $40,000 to $70,000. A bicycle path encircled the 4-acre pond, with its dock and gazebo, and the pond was stocked with bream and catfish. This photograph is dated 1980.

On Peachtree City's Village Green in May 1977, two reenactment battles arose between "Colonials" and the "British and Loyalists." Over two days, visitors could watch battles and see the 18th-century encampment. A mock execution took place as well as a mock wedding. When the battles were over, Colonial muster participants watched while Frank Medley's hot air balloon soared aloft along with two others. Only the modern bicycle belies the true time period.

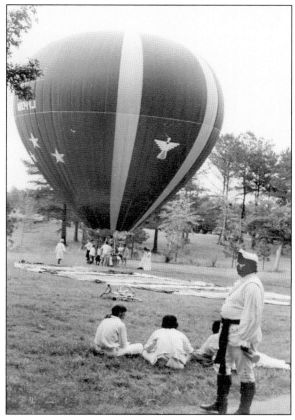

Tom Hughey, an off-duty fireman, assists at the scene of a head-on collision at the intersection of Highways 74 and 54 sometime in the 1970s. Both roads are today multilaned and traffic-packed. In the distance, one can see the completed bicycle bridge over Highway 54 West. However, Westpark Walk is not yet in view and, apparently, neither is the first traffic signal—which came in 1977. (Courtesy of the Peachtree City Police Department.)

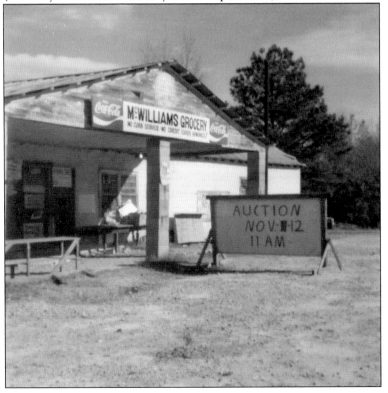

After "Mister Dave" McWilliams's death in January 1977, store items were put up for auction. The cheese knife inside had come from his Clover store, and some of the display cases had occupied Kirkland's 1907 Aberdeen market. Early Peachtree City plans had been tossed around the potbellied stove in McWilliams's shop, a good place to hang out and warm up. And one of the first council meetings was held there in June 1960. (Courtesy of Melvin Brown.)

Around the same time the McWilliams Store was liquidating its wares on Highway 54 West in 1977 after the death of longtime merchant Dave McWilliams, the Kwickie Food Store was getting underway across from Willowbend Center on Highway 54. It opened for business in March 1977.

James Clarence Hanchey, owner of the Gulf service station in the late 1970s, lived in nearby Tyrone and had at times served as mayor and councilman of that town. He was the fourth owner of the business on Highway 54 near Willowbend Center. When the station was newly built in 1965 by Gerald Jones and Thomas Crews, one of its bays was offered to house the city's first fire truck.

Few restaurants existed in 1977 when Jim Royal opened his own pizza den in a former clothing store at Aberdeen Village Center and called it Partners II Pizza. It was a welcome lunch alternative for workers in the industrial park and a great meeting place for small groups. (Courtesy of Jim and Marilyn Royal.)

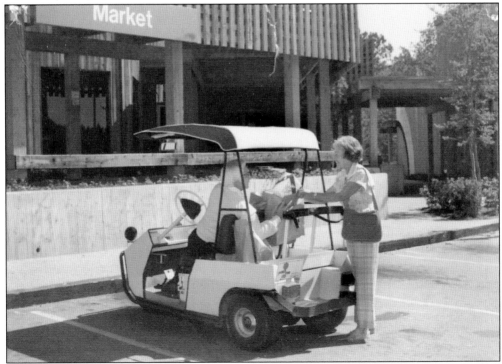

Mayor Howard and Dolly Morgan utilize their golf cart for a shopping trip to Aberdeen Village in 1975. The Morgans lived on Lake Peachtree, south of Highway 54, and so would have likely traveled over the bicycle bridge on their way to do their errands. (Courtesy of Dolly Morgan.)

By 1979, nearly 6,000 people called Peachtree City their home. As each village developed, a shopping center arrived to serve its residents. For Glenloch in December 1978, it was Peachtree Crossing, situated at the northeast corner of the intersection of Peachtree Parkway and Highway 54. Big Star, Peachtree City's first major chain grocery store, anchored and shared the center with Eckerd Drugs, Peachtree Crossing Travel Center, the Tree Hut, Cappie's Flowers and Gifts, the Club House, Peachtree Cart Mart, and dentist Dr. Kenneth Rundle.

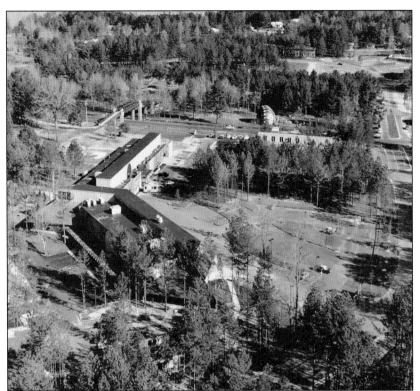

This aerial photograph of Aberdeen Village Center shows a hot air balloon on the south side of Highway 54 getting ready for take-off. In the distance at the far right of the picture can be seen the Pebble Pocket tennis courts.

In this aerial view looking north toward Highway 54, one can see the way the railroad line and Highway 74 parallel each other. The large facility near the center of the picture is NCR Corporation's World Parts Center. One can just make out the Hi-Brand Foods building at the intersection of the two main roads. Westpark Walk has not yet been developed. Clearly visible is the division of the industrial park west of Highway 74 and the residential areas east of the highway.

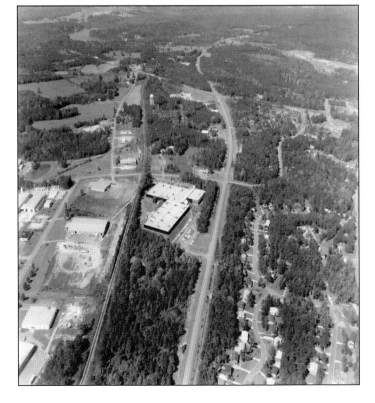

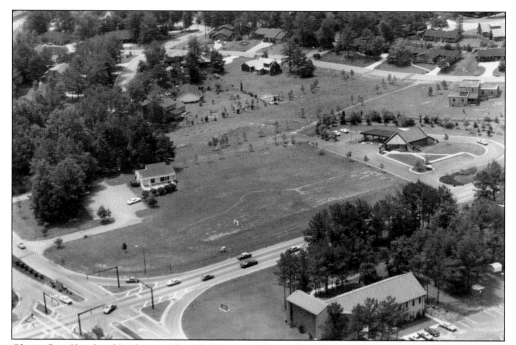

Christ Our Shepherd Lutheran Church (foreground) stands at the northwest corner of the Peachtree Parkway–Highway 54 intersection. The Reverend John Martin Weber led the congregation from its first worship service in December 1974, before the church was built, until he retired in the summer of 2008. He gave 34 years of service to the community through the church and as chaplain for the Peachtree City fire and police departments.

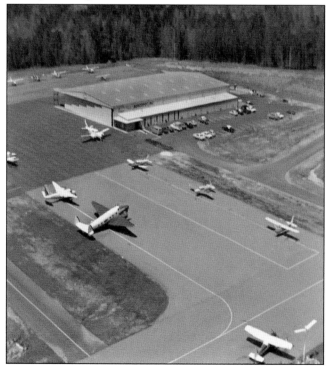

Wayne Hutcheson managed the Aerospec Building at Falcon Field and guided maintenance of all types on the planes brought to Falcon Field for refurbishing. Whether it was for a paint job, reupholstering, or installation of new electronic equipment, the job could be accomplished by experts at the small air field south of Atlanta.

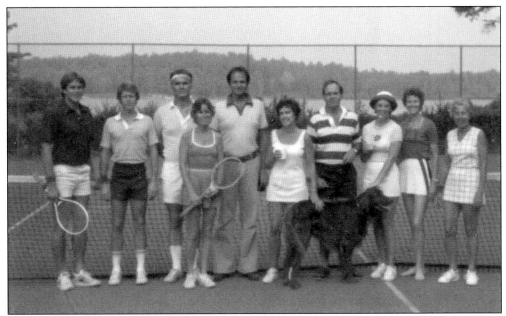

Joel and Geri Cowan hosted annual Fourth of July neighborhood tennis tournaments at their home from 1972 until 1979, adding new players to the roster as the town grew. Some of the players at the Cowans' one year are, from left to right, unidentified, David Trout (Geri's nephew from Marietta), Wynck Kirk, Gail Broderick, unidentified, Brownie Jones, Sam Brannon, unidentified, Geri Cowan, and Dolly Morgan. (Courtesy of Joel and Geri Cowan.)

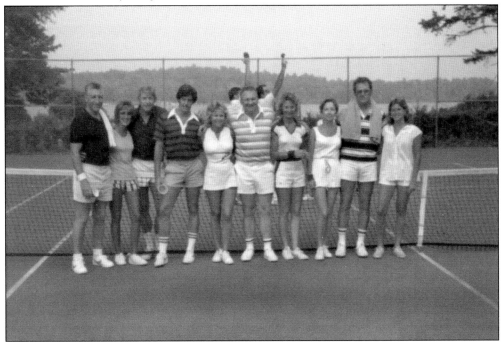

Others attending one of the annual tennis tournaments are, from left to right, Vince Rossetti, Marilyn Smith, Bill Cawthorne, unidentified, Billie Awbrey, Roy Henson, unidentified, Paula Dougherty, Ralph Jones, and Sandra Brannon. (Courtesy of Joel and Geri Cowan.)

In 1978, Jimmy Booth hired young artist Henry Dale House to help publicize the relocation of the *This Week* newspaper offices. House designed this map, which highlighted the landmarks of the time and pointed out both the newspaper's old location in the municipal building east of the cart bridge and the new location west of town beyond the Totem Poke, Jim Hudson's convenience store (opened in 1975), and Line Creek Baptist Church.

In 1974, the Aberdeen Bottle Shop opened in the new Willowbend Convenience Center. It would later, in 1978, relocate across the road on Highway 54 East. Though the shop has changed ownership in the intervening years, it remains a "bottle shop" selling wine, beer, and spirits.

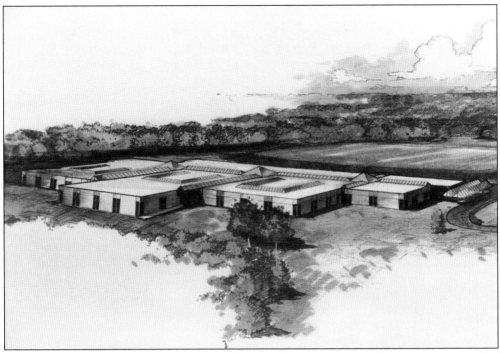

Pictured below is James Cecil Booth, a well-loved educator in Georgia for over 40 years, 15 of them in Fayette County. He died in 1971. The architectural rendering above reveals the school in Peachtree City that would take his name. The J. C. Booth Junior High School began at Fayette County Junior High in August 1978, where students and teachers from both schools attended in double sessions. When the Peachtree City building was completed in January 1979, Booth students and faculty transferred to the new facility. In 1990, the middle school model was adopted, and the name changed to J. C. Booth Middle School. (Below courtesy of the Fayette County Historical Society.)

A young Danny Allen, son of Glen and M. T. Allen, gets his picture snapped next to the celebratory cake for the city's 20th anniversary. Note that the confusion about the city's name was an issue even in 1979. The word "City" had to be applied to the cake as an afterthought—apparently the baker was not from "around here."

Musical entertainment for the city's anniversary party was provided by bluegrass band Brush Fire, whose lead singer and guitar player, Mike Fleming, was the son-in-law of future mayor Fred Brown Jr. Eddie Turner was the tenor and mandolin player; and Joe Partridge sang baritone and played bass or banjo.

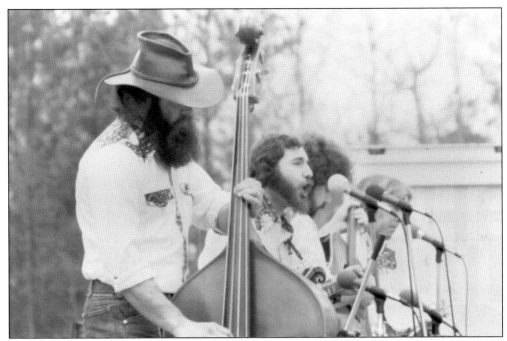

Brush Fire was known for their tight harmonies, and they became minor bluegrass celebrities on the southeastern bluegrass festival circuit. They played a number of times at the amphitheater when it was the McIntosh Opry.

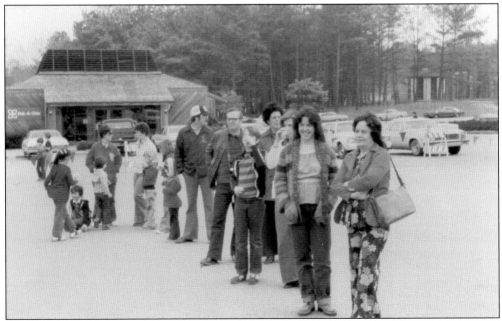

The 20th anniversary of Peachtree City, in 1979, brought a week of special events: Recreation Day on Monday, March 5, and Spirit Day on Tuesday. Wednesday was Industry Day, when industrial plants opened for tours. Thursday—Merchants Day—offered special sales. Friday was Students Day, with essay and poster contests, a skating party, and a dance. On Saturday, Peachtree Citians attended a block party at Willowbend, pictured here.

The Georgia Cloggers from Miss Patsy's School of Dance perform in celebration of Peachtree City's 20th birthday at the block party at Willowbend Center.

Here, at one of the Antique Car Festivals from the 1970s, which were sponsored by the Peachtree City Optimist Club, browsers admire the fine details of some beautifully restored old Fords. Jack Miller of RoseMill Homes, whose partner was Vince Rosetti, had many antique cars in the shows and would also use them in advertising for the company. Several cars also joined the parade in 1979s anniversary celebration.

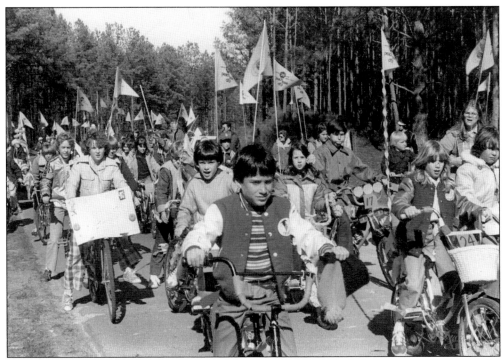

On Sunday, March 11, the Boy Scouts led paraders from Glenloch Information Center to the municipal complex. The procession included school bands, Freckles the Clown, the John Mohr Mackintosh Pipes and Drums (below), and the Kiwanis-sponsored bicycle brigade (above). Three thousand people stood along the streets to watch. Later, at McIntosh Amphitheatre, many parade participants performed, as well as the Booth Jr. High School Band and Chorus. Mayor Herb Frady led the crowd in singing "Happy Birthday, Peachtree City." Bob Price introduced the town's first mayor, Joel Cowan, who said, "I feel a thrill every time I drive around the city. Peachtree City was conceived as a dream and nurtured with love. The people here reflect that love."

Six

ON THE EVE OF THE 21ST CENTURY

The first Shakerag Arts and Crafts Festival took place in June 1976. Held in both spring and fall for many years, the festival attracts thousands to the McIntosh Arts Trail Complex in Peachtree City. The event is an opportunity to view the works displayed and offered for sale by local artists and craftspeople, and to enjoy the food, music, and other entertainment. Shown here is some of the crowd attending the fall 1980 festival.

Several members of this party smile for one camera while being snapped by another at the annual Spring Fling, a staple of the 1980s. The event was sponsored by the recreation department. From left to right are M. T. and Glen Allen, Shirley Frady, Mary Maher, and Herb Frady.

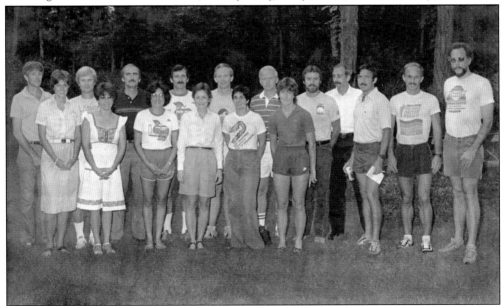

The Peachtree City Running Club is one of dozens of organizations reflecting the many talents and interests of the residents. Shown here are the charter members of the club when it was organized in 1981. One of the club's events has been its annual Peachtree City Classic, which is held on the city's many miles of multiuse paths. In 1981, this race attracted 300 runners and grew to over 2,000 participants by 1988. (Courtesy of the Peachtree City Running Club.)

Built in 1979 by a team of dedicated volunteers, Peachtree City's William L. Davis BMX Facility (known as the Peachtree City BMX Track) attracts riders from all over Georgia. In 1990, the facility hosted a portion of the National Bicycle League's national circuit. And, in 1995, the track was filmed by a television crew for the TBS cable network show *Feed Your Mind*, a weekly series geared toward schoolchildren.

Peachtree City's multiuse paths attract all types of users—golf carters, bikers, skaters, runners, and walkers—of all ages. Here some young budding athletes show their talents in the 1984 Fun Run sponsored by the Peachtree City Running Club.

Herb Frady, Peachtree City mayor from 1978 through 1981, had worked for Davis Brothers Restaurants in Atlanta as a young man. When he and his wife, Shirley, moved to Peachtree City in 1975, they were interested in obtaining two things: land for horses and a restaurant opportunity. Frady's Restaurant lasted until 1985, when it burned to the ground. Frady, a pilot, went on to fly for M. A. Industries and serve on the county commission.

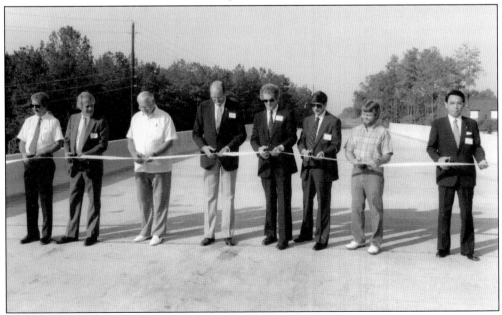

The building of the TDK bridge over the railway was an important step in providing the infrastructure necessary to continue the growth of the industrial section in the southern part of the city. Here key people gather for the ceremonial ribbon cutting. Shown from left to right are Stan Neely, Steve Black, unidentified, Mayor Fred Brown, Doug Mitchell, Mukat Gupta, an unidentified contractor, and a representative from TDK Electronics.

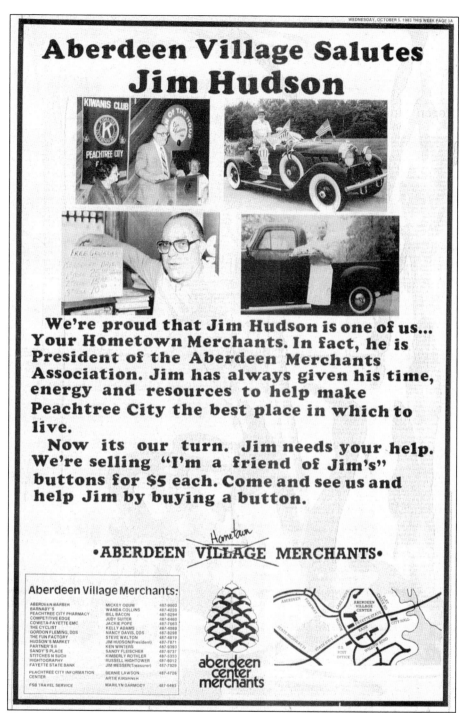

Jim Hudson owned and operated the first modern grocery store in Peachtree City and was a popular businessman in the new town. Hudson's Village Market Food Store was located in the Willowbend Shopping Center until November 1974, when it moved to the Aberdeen Shopping Center on the north side of Georgia Highway 54. When Hudson became seriously ill in the 1980s, the Aberdeen Village merchants raised money for him by selling "I'm a friend of Jim's" buttons for $5.

Ted Thomas (center), chairman of the Peachtree City Planning Commission, presented resolutions of appreciation to Jim Strickland (left) and city clerk Frances Meaders (right) in May 1982. Strickland had served for six years as a member of the planning commission, and Meaders had served nine years as the commission's clerk.

Service clubs, such as the Rotary Club, Kiwanis Club, Golden Kiwanis Club, and Optimists Club, make invaluable contributions to Peachtree City. Pictured above are several members of the Optimists Club from the 1980s. They are, from left to right, (seated) Hank Galloway, Bob Grove, Vince Rosetti, and Jack Hollister; (standing) Russell Hightower, Randy Brown, Dr. Rod Justice, and Bob Cheek. The Optimist Club was formed in Peachtree City in 1974 with 35 members. The activities of the Optimists Club include its Childhood Cancer Campaign, Food Drive for the Needy, and Youth Appreciation Week.

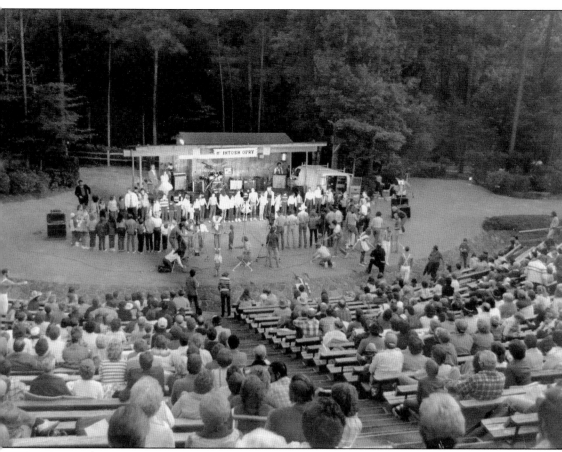

In 1978, Peachtree City purchased the 25-acre McIntosh Trail Arts Center in a public auction. In 1982, when the McIntosh Opry was in its fifth season, a free show was held in the amphitheater each Saturday night from April 24 until September 25. The best of bluegrass, country, country rock, folk, and gospel music could be heard, and exhibition clogging acts were featured. (Courtesy of Glen Allen.)

Mayor Fred Brown (right) and Japanese foreign minister Masayoshi Ito greet each other in front of the TDK building sometime in the early 1980s. TDK and other Japanese companies opened several plants in Peachtree City and became important contributors to the community.

Built by the Sheraton in the early 1980s, this facility was later renamed the Peachtree Executive Conference Center. It is now the Wyndham Peachtree Conference Center.

In 1984, Peachtree City celebrated its 25th anniversary. There were many special events to note the occasion, including a gala dinner and dance. Peter S. Knox Jr., the man with the dream that became the planned city, was there for the celebration. Knox (left) is seen here at the dinner with Joel Cowan (right). They are the men who formed the partnership that made Peachtree City possible.

Kevin Moody (center) pauses for the photographer with Jerry Peterson (right) and Rick Black of Century Designs at an open house gala for one of Moody's creations. Kevin Moody was still a 22-year-old senior at Georgia Tech when he designed and built his first house in Peachtree City, in Spyglass Hill. He went on to be quite a successful builder. Jerry Peterson, an architect and land planner, had a history with several other planned communities before landing in Peachtree City at the behest of Doug Mitchell in 1977. Peterson and Mitchell, along with Steve Black, were instrumental in the growth of the city in the 1980s and 1990s. Peterson named many of the streets in Peachtree City.

Carts are lined up for the Great Peachtree City Golf Cart Rally. Sponsored by the Parks and Recreation Department in the mid-1970s, the autumn event was designed to get residents better acquainted with the cart trails. In 1975, sixty carts participated, 30 of which were loaned by Westinghouse (later HMK Marketeer, Ltd.) to preregistered residents without carts of their own. Lou Morgan and Jim Raines were the first-place winners.

Family life in Peachtree City can be a very busy time, filled with many school, athletic, church, and club activities, but this scene from the 1980s shows that children and parents can also "escape" on their golf carts for a quiet time at Lake Peachtree.

The developers became master marketers to sell those who were newly transplanted to Georgia on the benefits of Georgia's "New Town." Many advertising campaigns worked to get the message out that Peachtree City was the "city for families" and to tell visitors "you'll love to call it home."

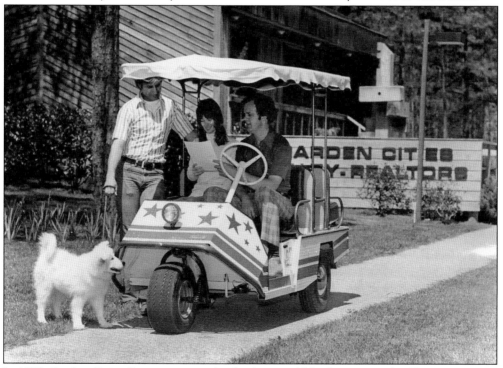

In 1976, Garden Cities Corporation used red, white, and blue bicentennial golf carts to attract prospective home buyers to Peachtree City. In the photograph, Maurice Brown Jr. (right) of Garden Cities Realty talks to visitors Dennis and Janella Krier. (Photograph by Warren L. Bond Studios.)

Don Jones (standing) was the first owner of Omega Books in the Peachtree Crossing Shopping Center. Though Omega was not the first bookstore in Peachtree City, his would be the first full-line one to last, surviving even the challenge of national chain Books-a-Million. After opening the business in 1986, Don sold the store to his longtime employee Karen Duncan and her husband, George, in 2000. Here Don is seen with former U.S. senator Max Cleland (seated), one of many author celebrities the store has hosted for book signings over the years. (Courtesy of Omega Books.)

It was 1973 when the first library was organized with the help of city attorney Wright Lipford and 100 members who made up the library corporation; they would serve as library builders in every sense of the word. The corporation's first officers were Tutt Cawthorne, president; Ginny Ellis, vice president; Geri Cowan, secretary; Dave Satterthwaite, treasurer; and Phil Colston, advisor. The organization was supported by Garden Cities as well as both the Kiwanis and Rotary civic organizations.

M. T. Allen (second from left) here at the 1986 ground-breaking for the new library, was library manager for the city's library from 1985 to 2007. Succeeding Jenny Pyron and Willard Bryant, M. T. took the library from a small room with donated books to a fully functioning arm of the city. M. T. was civic minded and a personable spokesperson for the city's library. She made friends easily and was well-loved by the community as the longest-running librarian in the city's history. Pictured are, from left to right, state representative Paul Heard, Allen, Dorothea Redwine, Sen. Bev Ingram, and Jimmy Booth.

Hilda Bruce Loyd Farr was born in Aberdeen in 1917 and attended Oak Grove School, Fayetteville High School, and Bessie Tift College, later teaching school in Senoia and Tyrone. It was she who suggested the name for today's Oak Grove Elementary School. Walter Floy Farr was born in Tyrone in 1912 and attended elementary school there and high school in Fayetteville. He later rode the train to downtown Atlanta to attend the Atlanta Business College and went to work for Redwine Brothers Bank in Tyrone. The pair raised two sons, Walter F. "Sonny" and Thomas, and moved to Peachtree City in 1965 as pioneer citizens helping to build the town. Here they are in attendance at the ground-breaking for the new library.

In 1987, students of McIntosh High School were on the academic game show *High Q* hosted by Channel 2's Glenn Burns. Pictured from left to right are seniors Cameron Allred and Christopher Riggins, host Glen Burns, Steve Cowgill, and an unidentified student.

The McIntosh High School Band is pictured here around 1987. (Courtesy of Paul Talbott.)

The Peachtree City Classic began in 1981 and quickly became a popular annual event for local runners, as well as many others from the larger Atlanta metropolitan area. The extensive tree-shaded path system in Peachtree City made the event a natural for runners of all abilities. The eighth annual classic in 1988 attracted 2,135 entrants. Phil Richey of Marietta, Georgia, is shown here crossing the finish line as the winner of the 15K. (Courtesy of the Peachtree City Running Club.)

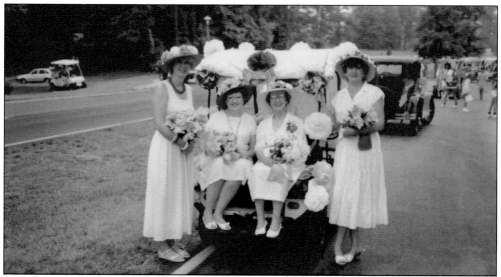

The Fourth of July Parade is a big event in Peachtree City each year with hundreds participating. The parade includes bands, floats, horseback riders, and, of course, local politicians. But the Fourth of July Parade in Peachtree City is unique because it also includes dozens of cleverly and, in some cases, lavishly decorated golf carts. In 1988, Peachtree City Garden Club members, shown from left to right, Anita Vaughan, Connie Lowery, Margaret Smith, and Christine Denninghoff were prize winners for their colorful use of flowers on their golf cart and their festive outfits. (Courtesy of the Peachtree City Garden Club.)

The Braelinn Golf Club, an 18-hole course and driving range, opened on July 4, 1988. The Braelinn Club was the second golf course built in Peachtree City and was located in the southern part of Peachtree City.

Peachtree City's first Kroger at Braelinn Village was highly anticipated. Crowds flocked to the grand opening, which was attended by, from left to right, architect David Ogram, Peachtree City Development Corporation president Doug Mitchell, Mayor Fred Brown, and contractors Stephens and Tribble.

Jimmy Booth (right), original owner and publisher of *This Week* newspaper, chats with C. J. Mowell at Peachtree City's 30th anniversary celebration at city hall in 1989. In the background are historical pictures from the city's first 30 years, many of them originating from Booth's time with the newspaper, which he had sold in 1982. (Courtesy of Frances Meaders.)

Rep. Dan Lakly (third from the left) queues up to sign the guest book at the 30th anniversary reception. Active in politics for many years, he had also served on the city council and the county commission. Lakly passed away suddenly on October 29, 2007, at the age of 65. Soon after his death, a short stretch of road alongside the city's first McDonald's was named in his honor. For years, it had been his morning ritual to meet with a few friends for breakfast at the restaurant. (Courtesy of Frances Meaders.)

Sallie Satterthwaite, a Fayette County Woman of the Year in 1977, holds up her end of the fire department's banner along with Carol Talbott, wife of fireman Paul Talbott. (Courtesy of Paul Talbott.)

Founding members of the Peachtree City Fire Department pose in front of Engine 82 in 1991. They are, from left to right, Al Hogg, Wendall Waggoner, Ralph Jones, M. D. "Brother" Leach, Jack Walls, J. K. Conner, Tommy Broderick, and Arnold Cheek. (Courtesy of Sallie Satterthwaite.)

Debi Lenox, wife of Bob Lenox, who would have one of Peachtree City's longest runs as mayor (serving from 1991 until 2001), shot the winning photograph in the 1992 Peachtree City Photo Contest. Depicting local firemen participating in the annual Water Battle on the Fourth of July, the picture was a sure*fire* winner! (Courtesy of Debi Lenox.)

Satterthwaite Fire Station No. 84 opened in 1994 in Kedron Village. In the same year, two new engines were purchased for the department; a few years later, a large "heavy rescue" truck was added. Sallie Satterthwaite was the first woman to serve on the Peachtree City Council. She volunteered for many years as an emergency medical technician. Sallie has chronicled much of the history of Peachtree City and continues to write for the *Citizen*. (Courtesy of Sallie Satterthwaite.)

Peachtree City Garden Club representatives walked the "Strolling Place" at Hoshizaki America, Inc., where the remnants of an old moonshine still were preserved on the property. The still is one of several known to have existed in the Shakerag vicinity both during and after Prohibition. Pictured from left to right are Helen Margrave, Ginnie Joyner, Marie Barr, and Dean Coursey. (Courtesy of the Peachtree City Garden Club.)

Operating plants worldwide, Hoshizaki is one of the largest manufacturers of commercial ice and food service equipment. At the Peachtree City facility, Japanese citizens, who spend five-year terms at the plant, make up a small portion of the workforce. The company opened a nature trail for employees around 1985. In 1994, commemorating the visit of the company's founder, the strolling place is named for Shigetoshi Sakamoto. (Photograph by Ellen Ulken.)

Dennis Chase speaks to Peachtree City Garden Club members about the importance of the wetlands at the Flat Creek Nature Preserve boardwalk during an outing in 1997. (Courtesy of the Peachtree City Garden Club.)

Frances Meaders retired as the longest-running city clerk, having served five different mayors—two of them long-serving mayors. Shown here are, from left to right, Bob Lenox, Frances Meaders, Fred Brown, Herb Frady, and J. K. "Chip" Conner. Though she had also worked with Howard Morgan, who hired her in 1973, he died prior to her retirement. (Courtesy of Frances Meaders.)

Newt Gingrich brought his "Congressional Mobile Office" to Peachtree City in 1976 while campaigning for Georgia's Sixth District Congressional seat. Gingrich promised that a motor home would serve as one of his regular congressional offices, traveling frequently through the 14 counties in the district. Although unsuccessful that year, Gingrich was elected to Congress in 1978 and was reelected 10 times. He served as Speaker of the U.S. House of Representatives from 1995 to 1999.

Peachtree City welcomed former president Jimmy Carter to its Fourth of July celebration in 1995. President Carter was the grand marshal in the annual parade that year. He is seen here being greeted by Mayor Howard Morgan at the reception for him in city hall. President Carter's son Jeff and his family live in Peachtree City, and the former president has visited the city many times over the years. (Courtesy of Dolly Morgan.)

Sallie Satterthwaite gathered together all former mayors as of 1995 to capture this picture of them around the Information Center's relief map. Shown from left to right are Bob Lenox (1992–2001), Frederick Brown Jr. (1982–1991), Herb Frady (1978–1981), Howard Morgan (1972–1977), J. K. "Chip" Conner (1970–1971), Ralph Jones (1966–1969), and Joel H. Cowan (1959–1965).

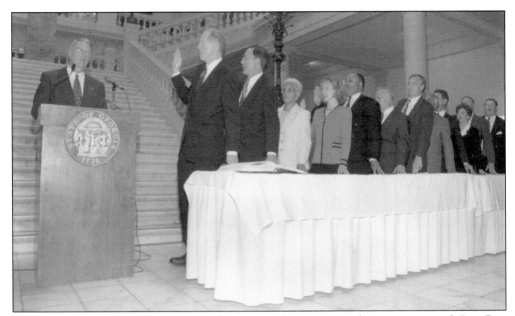

Joel Cowan's reputation for long-range land use and community planning prompted Gov. Roy Barnes to appoint Cowan in June 1999 to head the board of the newly created Georgia Regional Transportation Authority. GRTA was created to combat air pollution, traffic congestion, and poorly planned development in the rapidly growing Atlanta metropolitan area. (Courtesy of Joel H. Cowan.)

Karen Duncan (right), of Omega Bookstore, and her husband, George (left), purchased the store from its founder, Don Jones (not pictured), in 1999. The store has hosted many important authors in its 23 years. Here Zell Miller, former U.S. senator and Georgia governor, was in town for a book signing. (Courtesy of Omega Books.)

Peachtree City Police Department was the first in Georgia to receive accreditation from the Commission on Accreditation for Law Enforcement Agencies, Inc. (CALEA). The force has grown along with the city to create and maintain a feeling of security in the community. (Courtesy of Peachtree City Police Department.)

Partners II Pizza opened at a number of other locations in the years since it began the first restaurant at Aberdeen in 1977. It is the oldest surviving restaurant in Peachtree City and has expanded its original location multiple times until it now consists of several dining rooms that were once neighboring businesses. In this 2004 picture, from left to right are James Robison, Marilyn Royal, and Jim Royal. (Photograph by Leita Cowart.)

On July 17, the 1996 Olympic Torch Relay entered Peachtree City on Highway 54 from Newnan, looped into the plaza at city hall for a festive celebration, and continued its journey south along Highway 74. Chris Davis was one of those among several area residents who had the honor of carrying the torch along the route to its final destination in Atlanta. (Courtesy of Sallie Satterthwaite.)

The members of the Peachtree City Running Club relaxed and partied after all their hard work as hosts to the National Convention of the Road Runners Club of America held in the city in 2000. The club is certainly not "all running and no play." (Courtesy of Peachtree City Running Club.)

Southern Nights Chorale is a men's precision á cappella ensemble made up of singers from the south metro Atlanta area. Many of the singers live in Peachtree City. They rehearse in Fayette County but sing throughout the Atlanta region. In the picture, the group performs "The Star Spangled Banner" at Turner Field during a June 2007 Braves game. J. D. Holmes is conductor, and Marcia Cutler is a pianist and concert assistant. (Courtesy of J. D. Holmes.)

At Kedron Elementary School, when the day ends, many children are fetched home by golf cart. After the noisy buses leave, the carts—30 or 40 of them—crawl silently alongside the school portico. Parents, surrounded by pets and other children, load up their kids and make a teacher-assisted, orderly procession away from the building. They enter the tree-lined golf cart paths, creep up and over the Kedron hills, and follow their separate ways home. (Photograph by Ellen Ulken.)

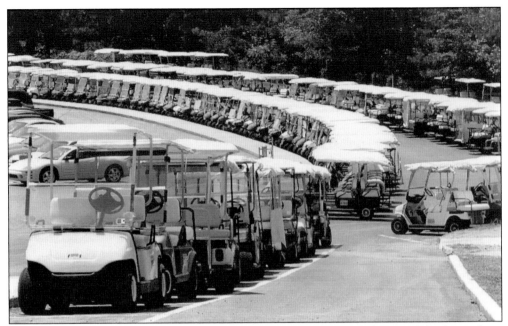

McIntosh High School students in good academic standing may purchase and display parking permits for cars or golf carts and may park in student-authorized areas at the school. The cart lot is pictured above. Seniors get first priority, then juniors and sophomores. The campus speed limit is 5 miles per hour, and golf carts are ubiquitous. (Photograph by Dan Nelson.)

At the intersection of State Highways 54 and 74, also dubbed Floy Farr Parkway and Joel Cowan Parkway respectively, stands the welcome sign erected by the Rotary Club, which proudly proclaims the civic-minded organizations active in town. On the other three corners of the intersection are now shopping centers and eateries, the older Westpark Walk, and the newer upscale shopping promenade dubbed The Avenue. All are testament to the town's phenomenal growth and vitality. (Photograph by Ellen Ulken.)

The fountain in front of the library and city hall was designed and constructed in 1991 by Kajima International, Inc., and presented to officials and residents by Japanese companies operating in Peachtree City at the time—Furukawa Electric America, Inc.; Hoshizaki America, Inc.; Johnson Yokogawa Corporation; Kawasaki Loaders Manufacturing Corporation, U.S.A.; Panasonic/Matsushita; Communication Industrial Corporation; TDK Magnetic Tape Corporation; and Yamaha Motor Manufacturing Corporation of America. The beautiful municipal complex is the heart of the community. Peachtree City Library received a major renovation in 2005, increasing its size to 31,000 square feet and increasing its visibility in the community. Circulation has continued to climb since then, with the library now the fourth busiest in PINES, the statewide consortium that includes over 270 public libraries across the state. Jill Prouty serves as library administrator with a dedicated staff of three professional librarians and 14 support staff. (Photograph by Freddy Frank.)

DISCOVER THOUSANDS OF LOCAL HISTORY BOOKS FEATURING MILLIONS OF VINTAGE IMAGES

Arcadia Publishing, the leading local history publisher in the United States, is committed to making history accessible and meaningful through publishing books that celebrate and preserve the heritage of America's people and places.

Find more books like this at
www.arcadiapublishing.com

Search for your hometown history, your old stomping grounds, and even your favorite sports team.